IMAGES
of America

HAGERSTOWN FIREFIGHTING

THROUGH THE YEARS

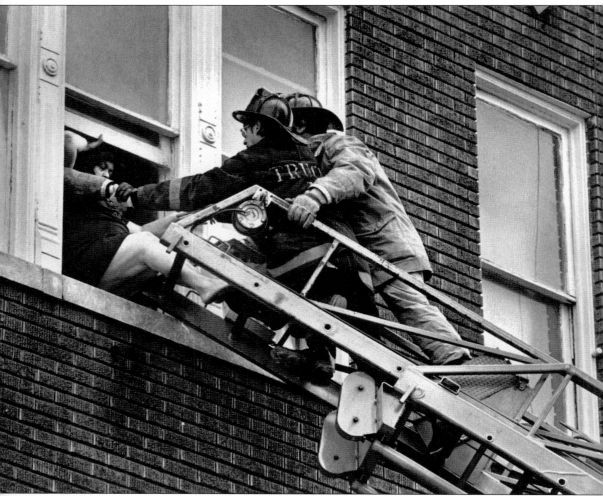

At 9:30 a.m. on the morning of February 1, 1977, the fire alarm bells in each of Hagerstown's firehouses tapped out box alarm 625, indicating a possible fire in the unit block of West Washington Street. The first apparatus to arrive encountered heavy smoke coming from the building. Residents were hanging out of the windows waiting to be rescued. The Pioneer Hook & Ladder Company's 1973 Oren/Hendrickson aerial ladder truck's ladder was raised to the windows. An infant, teenager, and two mothers were rescued from the windows. In this photograph, Fire Apparatus Operator (FAO) Robbie Dieterich is assisting a resident out of the window onto the aerial ladder where Firefighter Glen Giffin (foreground) and FAO Richard Cramer (background) assisted her to safety. (Copyright *The Herald-Mail* Company.)

IMAGES
of America

HAGERSTOWN
FIREFIGHTING
THROUGH THE YEARS

Justin T. Mayhue

Published by Arcadia Publishing
Charleston SC, Chicago IL, Portsmouth NH, San Francisco CA

Printed in Great Britain

Library of Congress Catalog Card Number: 2005925273

For all general information contact Arcadia Publishing at:
Telephone 843-853-2070
Fax 843-853-0044
E-mail sales@arcadiapublishing.com
For customer service and orders:
Toll-Free 1-888-313-2665

Visit us on the internet at http://www.arcadiapublishing.com

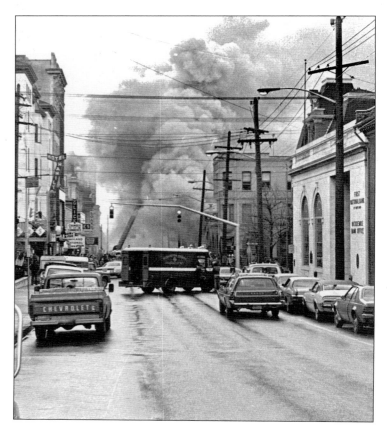

Heavy smoke billows from J. J. Newberry's Department Store located in the unit block of West Washington Street on Sunday, March 10, 1974. The fire went to eight alarms requiring more than 125 firefighters. Efforts to suppress the fire were hindered by brisk winds and the difficulty in getting water to the seat of the fire due to the building's construction. (Courtesy of the First Hagerstown Hose Company.)

CONTENTS

This volume is dedicated to the men and women who have faithfully served
the Hagerstown Fire Department from 1791 to the present.
May future generations look to the past with gratitude
for their sacrifices and commitment to protect
the lives and property of
the citizens of Hagerstown.

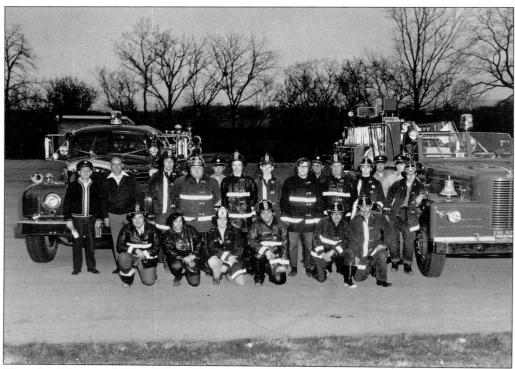

These firefighters and instructors were taking part in the 1973 Maryland Fire & Rescue Institute's Firemen's Basic Training class. Pictured from left to right are the following: (first row) Roy Lescalleet, Gordon Guessford, Sherman Horn, William Alder, Dave Gardner, and Ray Grim; (second row) Ray Dobbins, C. William Karn, Curt Hutzell, William Delauter, Mitchell Gearhart, Ed French, Don Mundy, Charles Barr, Robert Lewis, John Dellinger, Steve Smith, Charles McCoy, C. Kingsley Poole, and Doug Smith. (Courtesy of the First Hagerstown Hose Company.)

INTRODUCTION

This excerpt appears in the minute book of the Pioneer Hook & Ladder Company from 1873 and illustrates some of the difficulties facing firefighters at the time:

> On Monday night April 28 at about 8:15 p.m. an alarm of fire was communicated rapidly through the town. The direction of the fire was ascertained as soon as the truck was drawn from the house by the illuminated heavens in the northern sections of the town. The boys were remarkably prompt at getting out the apparatus as the neck to neck chase or rather drag/pull up the North Potomac Street hill indicated. After the scene of action was reached in advance of all of the other companies, the switch hook was quickly brought into service and did a fine execution by tearing to pieces the building, which was a frame stable belonging to Charles Reeder.

Each era has presented its own challenges for firefighters. When the United Fire Company was formed in 1791, leather buckets were used to obtain water from cisterns to fight fires. In the early and mid-1800s, hand-pulled and -operated four-wheeled pumpers or engines were utilized, accompanied by two- or four-wheeled hose reels. In 1871, the Independent Junior Fire Company introduced the first steam engine in Hagerstown. In the late 1890s—due to the increased size and weight of steam engines, hose carriages, hose wagons, and ladder trucks—horses were purchased by each company to enable faster response times. Prior to the 1890s, horses were rented from local livery stables to return an apparatus to the firehouse after an alarm, and they were also used for parades.

In the 1800s, several fire companies organized but soon disbanded after a number of years, including the United Fire Company, which was disbanded in about 1814; the Washington Mechanic Fire Company; the Franklin Union Fire Company, which was the predecessor to the Independent Junior Fire Company and which disbanded in 1842; and the Columbian Chemical Company on High Street, which incorporated in 1894 and disbanded in 1902.

Currently the Hagerstown Fire Department consists of six companies. Each has a minimum of one career driver/fire apparatus operator (FAO) on duty. The ladder trucks require two operators. Each company has a volunteer captain, volunteer firefighters, and volunteer administrative officers and members. The companies consist of the First Hagerstown Hose Company, Engine 1, incorporated in 1823; the Antietam Fire Company, Engine 2, incorporated in 1835; the Independent Junior Fire Company, Engine 3, incorporated in 1843; the Western Enterprise Fire Company, Engine and Truck 4, incorporated in 1872; the South Hagerstown Fire Company, Engine 5, organized in 1932; and the Pioneer Hook & Ladder Company, Truck 1, incorporated in 1872.

Management at fires has changed significantly through the years. Each volunteer company has always had fire officers, although their titles have changed. The leader of a company at a fire

scene has been referred to as chief engineer, chief marshal, and chief director. The titles for second in command were assistant engineer, marshal, director, and foreman. Prior to 1898, there was no overall fire chief in command at fires. At a convention of delegates from each company that year, Charles A. Spangler was elected chief engineer. Each year since then a chief was elected at the convention until a paid chief's position was created in 1948.

Currently the career portion of the fire department consists of a fire chief, a deputy fire chief, three battalion chiefs, three captains, three fire marshals, an administrative assistant, and a public fire/life safety educator. Career firefighters/FAOs drive the fire apparatus. Prior to 1966, an FAO was called a driver. Each career FAO is assigned to one of three shifts and each shift works 24 hours on duty with 48 hours off duty. Every three weeks, the FAO receives an additional day off called a Kelly Day. This makes the average work week 48 hours.

In this book, a piece of fire apparatus that contains a pump, water, and hose will be referred to interchangeably as a pumper or an engine. A ladder truck or truck carries ground ladders and has an aerial device, while a service truck has ground ladders but no aerial device.

I hope you enjoy learning about the cherished history of the Hagerstown Fire Department. Pay close attention to the details in each image—you will not only learn about the fire department but also the development of Hagerstown itself.

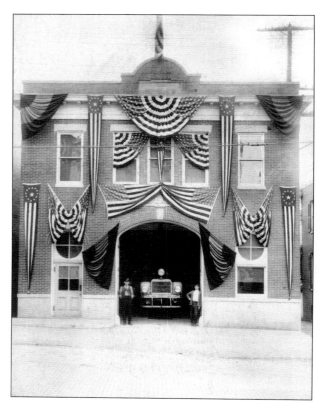

This is the first permanent home built exclusively for the Pioneer Hook & Ladder Company. It was constructed in 1915 on the Oak Spring property at 21 West Franklin Street. It had only one bay until 1934, when a second bay was added. The Pioneer's first home was on the market house property on North Potomac Street near Franklin Street. From 1893 until 1914, the Pioneers shared quarters with the Junior Fire Company at 105 North Potomac Street. In 1914, a political decision moved the Pioneers into the Antietam firehouse. After the Antietam firehouse burned in October 1914, the present firehouse was built. (Courtesy of the Pioneer Hook & Ladder Company.)

One

BUCKETS TO ENGINES
1800s–1919

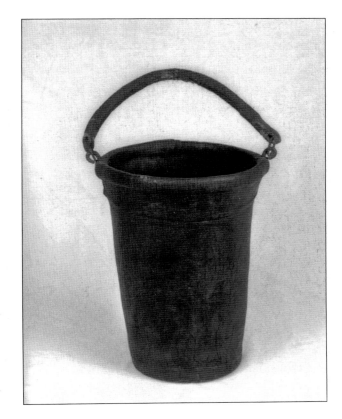

One of the earliest tools used to extinguish fires was the leather bucket. Water was dipped from cisterns and passed person to person in lines to the fire. Empty buckets were returned via another line back to the cistern. Women performed this task admirably. Buckets were used to extinguish chimney fires into the late 1800s. (Courtesy of the First Hagerstown Hose Company.)

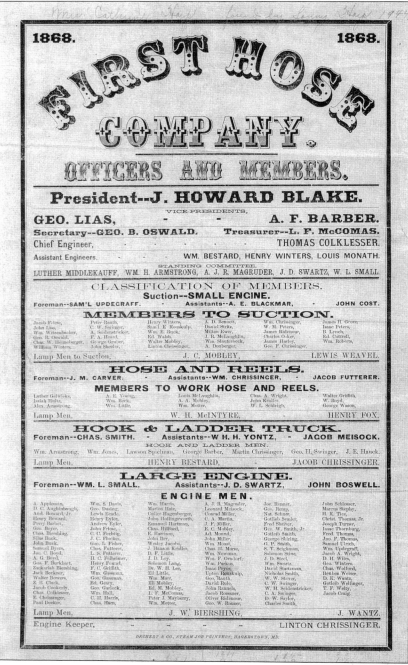

The First Hagerstown Hose Company was organized as early as 1815, a short time after the war of 1812. The first piece of apparatus was an old hand engine with a gallery. By 1868, the Hose Company was operating one large and one small hand pumper or engine, hose reels, and a hook and ladder truck. The ladder truck is believed to have been a two-wheeled hose reel with a ladder attached. The hand engines required many men to work the handles of the pump. The large engine alone had 127 firefighters assigned to it. (Courtesy of the First Hagerstown Hose Company.)

When the Shindle Tannery burned, this 1823 end-stroke hand engine was relocated to protect property on the opposite side of East Washington Street. Without a moment's hesitation, the boys took the engine known as "Pet" through the flames, which were leaping from the building. Several men suffered burns to their necks and faces, but the property was saved. (Courtesy of the First Hagerstown Hose Company.)

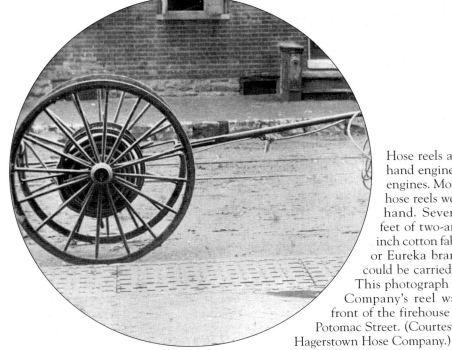

Hose reels accompanied hand engines and steam engines. Most two-wheel hose reels were pulled by hand. Several hundred feet of two-and-one-half-inch cotton fabric, Paragon or Eureka brand fire hose could be carried on the reel. This photograph of the Hose Company's reel was taken in front of the firehouse at 33 South Potomac Street. (Courtesy of the First Hagerstown Hose Company.)

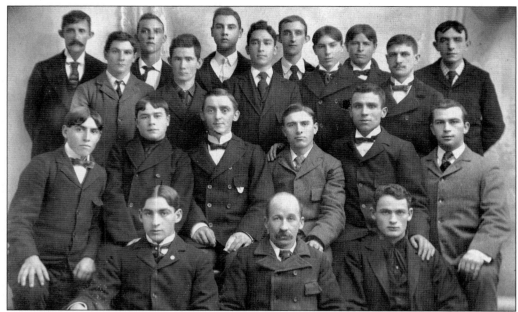

These handsomely dressed gentlemen are members of the 1897 Western Enterprise Fire Company hose reel team. Pictured from left to right are (first row) Wester Snyder, Harry Evans, and ? Largent; (second row) Cliff Minor, George Alexander, Charles Wellinger, ? Broguiner, Ben Donaldson, and Fax Snyder; (third row) Charles ?, unidentified, John Loudenslager, Fred Unger, and Ned Brogunier; (back row) Othe ?, unidentified, ? Kanels, Harry Lowe, Dusty Miller, and ? Daley. (Courtesy of the Western Enterprise Fire Company.)

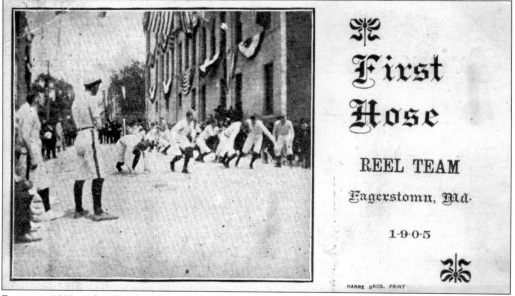

·Between 1893 and 1899, the Hose Company finished first or second in each hose reel competition it entered. They took home seven first place and two second place awards. Prize money ranged from $50 to $250. The winning times ranged from 37 to 53 seconds. (Courtesy of the First Hagerstown Hose Company.)

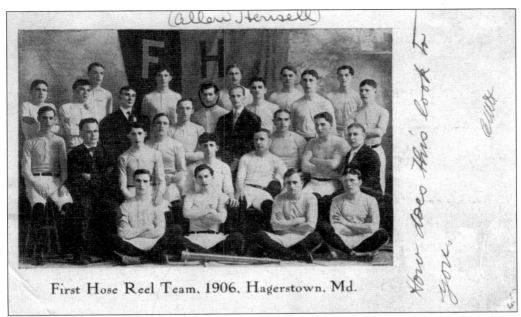

First Hose Reel Team, 1906, Hagerstown, Md.

This postcard shows the Hose Company's 1906 reel team. The card is addressed to Miss Cora Patton in Williamsport, Maryland. The postage was only 1¢. The man in the center whose head is circled is Allen Herrsell. (Courtesy of the First Hagerstown Hose Company.)

The Maryland State Firemen's Association holds an annual convention. In recent years, it has been held in Ocean City. The first convention was held in 1893 in Frederick. Delegates' badges are issued each year. The badge on the left is from the 1936 convention, hosted by Hagerstown. The badge on the right represents the Hose Company's participation in the Cumberland convention in 1896. (Courtesy of Photography by Dale.)

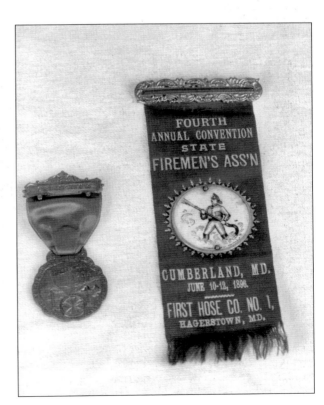

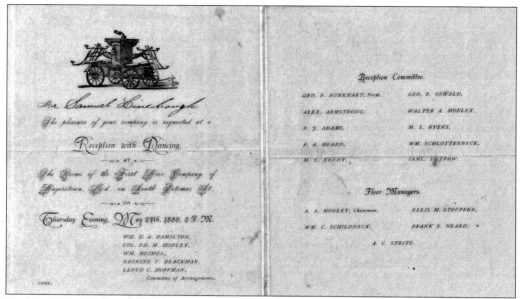

In the 1800s, firehouses or fire halls were the social and political pulse of the community. Dances, bazaars, fairs, and conventions were held in elaborate ballrooms. This is an invitation to a reception and dance in 1888 at the First Hagerstown Hose Company. (Courtesy of the First Hagerstown Hose Company.)

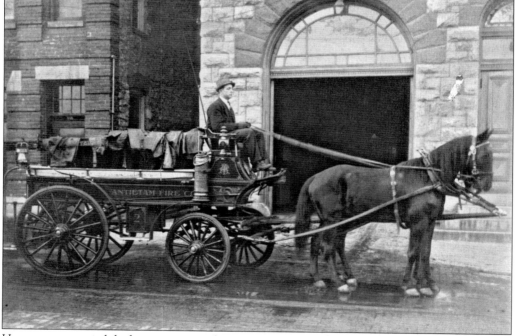

Hose wagons carried the hose to support the steam engines and hand pumpers. This is the Antietam Fire Company's hose wagon. The photograph was taken in front of the company's firehouse at 113 Summit Avenue. According to Antietam driver John Bomberger, the horses were like spoiled pets. People would often stop by to feed them. (Courtesy of the Antietam Fire Company.)

Hose carriages carried hose and were similar to a hose reel but had four wheels. This is the Independent Junior Fire Company hose carriage. By 1892, the Juniors had one steam engine, two hose carriages, and one hose cart. (Courtesy of the author.)

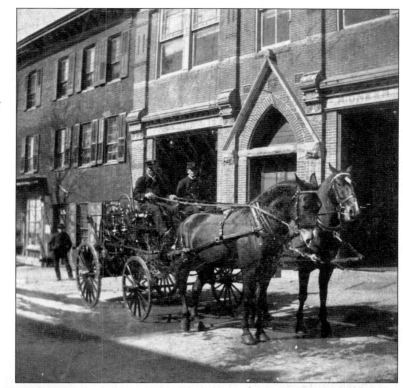

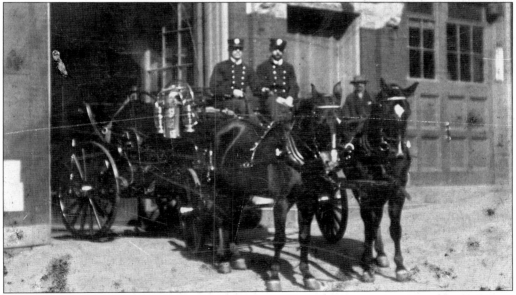

The Junior's horses Frank and Colonel are pictured pulling the hose carriage out of the firehouse. The horses required great care. They were fed two quarts of oats, one to two quarts of bran, cracked or ear corn, and mixed feed. They were exercised one hour in the morning and again in the evening. The stables required adequate ventilation, but the blinds were closed to keep flies out. (Courtesy of the author.)

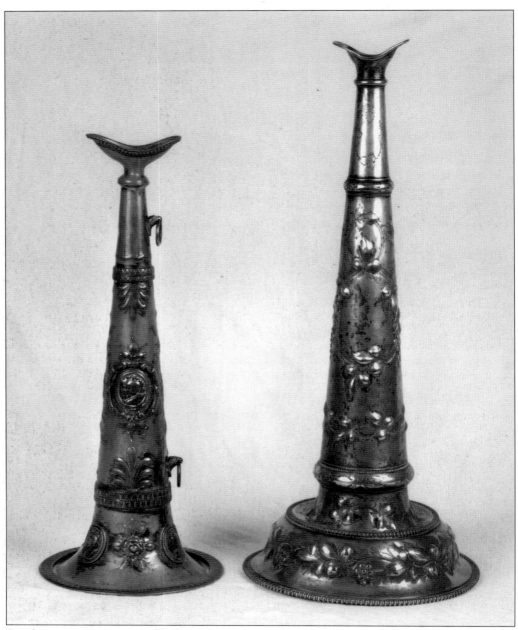

Speaking trumpets were used by fire officers in the early years of firefighting to amplify their voices when giving orders. In later years, the trumpets took on a more ceremonial role. On April 25, 1871, the Juniors purchased a steam engine from the Kensington Fire Company in Philadelphia for $2,750 plus 600 feet of hose. The steam engine replaced a famous hand engine known as "Big Six," which was sold to the City of Hagerstown for $1,000. The City then gave it to the newly formed Western Enterprise Fire Company. Accompanying the steam engine were these wonderful trumpets. The trumpet on the right was originally presented to Kensington by the ladies of Port Richmond on August 1, 1865. It was made by the Bechtel & Eno Company. The small trumpet was made by H. R. Eisenbrant Company in Baltimore. (Courtesy of Photography by Dale.)

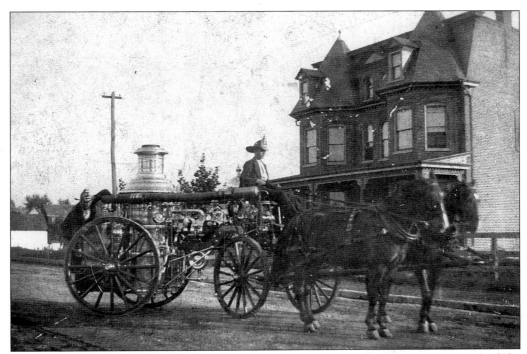

The Juniors replaced the steam engine purchased in 1871 with this 1880 steam engine built by Horace C. Silsby. Silsby was the largest manufacturer of steam engines, building 1,150 at the Island Works plant in Seneca Falls, New York. The driver is John Smith, who was one of the first career drivers for the Juniors. (Courtesy of the author.)

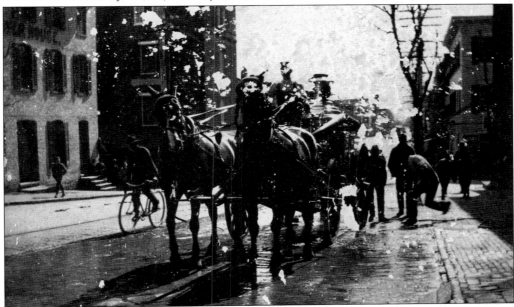

These Junior firefighters appear to be washing the Silsby steam engine. The Silsby had a rotary pump and was a class 4, meaning its pumping capacity was 600 gallons per minute. The manufacture number was 644. (Courtesy of the author.)

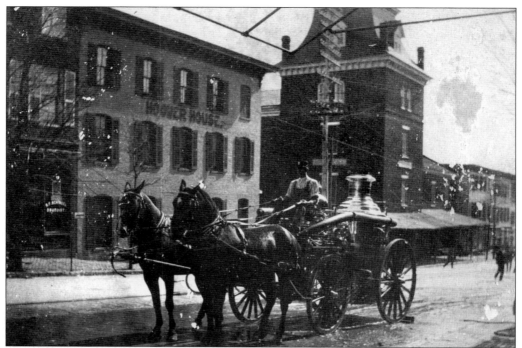

This is another view of the 1880 Silsby taken in front of the Junior firehouse at 105 North Potomac Street. The five-story building in the background is city hall. The City Market was on the ground level at the overhang. This was the first home of the Pioneer Hook & Ladder Company in 1872. In 1893, the Pioneers moved in with the Juniors. (Courtesy of the author.)

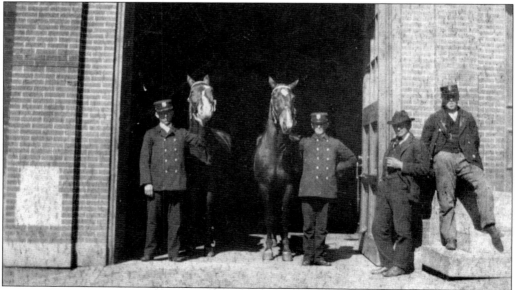

At the first stroke of Big Six (the fire alarm bell on top of city hall), Colonel and Frank rushed from their stalls to the front of the hall and waited under their harness for word to go. A poem was even written about the horses: "Frank and Colonel are little, but oh, my; when they strike the paved streets, they make the fire fly." (Courtesy of the author.)

It was not uncommon in the early 1900s for memberships to number in the hundreds or even thousands. In 1902, at least 167 members voted. That same year, the Juniors responded to 46 alarms and the total cost for firefighting was $969.32. (Courtesy of the Independent Junior Fire Company.)

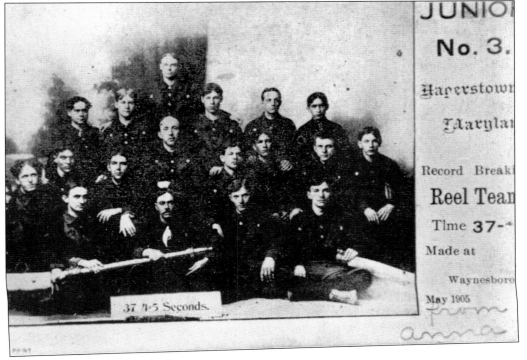

This postcard shows the Junior's reel team in 1905. The Juniors set a record of 34.80 seconds at a competition in Waynesboro, Pennsylvania. The Waynesboro team was always hard to beat. (Courtesy of the Independent Junior Fire Company.)

Western Enterprise Fire Co., HAGERSTOWN, MD.
Incorporated September 19, 1872.

CHARTER MEMBERS:

Lewis Delamarter, David S. Boyer,

Joshua D. Wise, William M. Tice,

Chas. E. Baechtel, Alex. A. Lechleider,

R. C. Bamford.

By 1872, it was felt that the three downtown companies could not adequately protect the city's West End. A meeting was called at the court house at which time the Western Enterprise Fire Company was formed. The men pictured signed the incorporation certificate. Lewis Delamarter was elected president, William Tice was elected treasurer, and R. C. Bamford was elected to the standing committee. (Courtesy of the Western Enterprise Fire Company.)

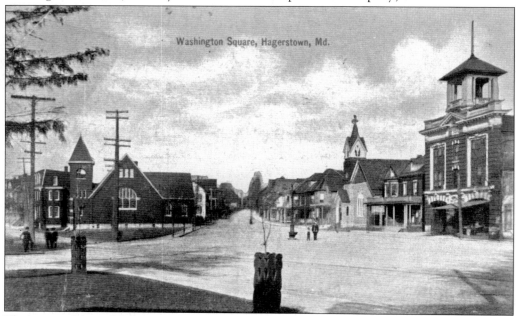

Washington Square, Hagerstown, Md.

This postcard shows Washington Square in 1910. The view is looking west up Washington Avenue. The Western Enterprise Fire Company, which was built in 1906, is on the right. (Courtesy of the David White collection.)

On March 6, 1874, a fire alarm circulated through town. Since the night was extremely dark and the streets muddy, the boys waited to hear if the alarm was real. After the Junior's reel and steamer passed in front of the truck house, the double bell of the German Reform Church sounded. The Pioneers responded, but the fire was already out on their arrival. This image of the Pioneers was taken in the Public Square about 1910. (Courtesy of the Washington County Historical Society.)

This 1911 Robinson combination pump, chemical, and hose wagon was Hagerstown's first motorized apparatus. The Robinson was first on alarms from 1911 until 1923. The Hose Company contributed $3,750 and city council contributed $5,250 to purchase the pumper. (Courtesy of the First Hagerstown Hose Company.)

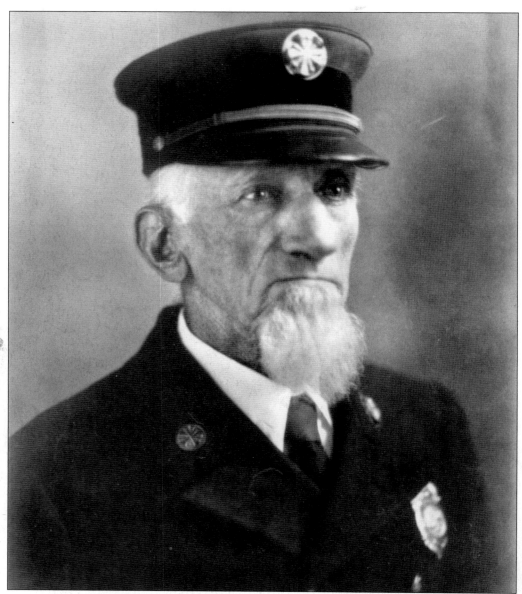

John Middlekauff served as Hagerstown's volunteer fire chief from 1907 to 1913. Chief Middlekauff was also the volunteer chief at the Antietam Fire Company and was known as a very knowledgeable and well respected leader. In response to Mayor Scott's request for information regarding the city's water supply, he sent a letter in 1910 that described conditions during a fire at Dr. Warham's residence on February 4, 1909: "it was from 30 to 45 minutes before there was sufficient water to make one good stream. During a test of the Enterprise steamer the firemen were obliged to flow water for ten minutes to clear the muddy water before using in the boiler to make steam." The chief recommended improving conditions at the Edgemont reservoir, adding 20 additional fire hydrants and two intakes for steamer service along Marsh Run, purchasing 2,500 feet of two-and-one-half-inch fabric hose, and flushing the hydrants every 30 days. (Courtesy of the Antietam Fire Company.)

The Antietam Fire Company erected this firehouse or fire hall in 1895. The design of the fire hall is typical of the building period known as "castles and palaces." The stone for the facade was obtained from the rear lot. (Courtesy of the First Hagerstown Hose Company.)

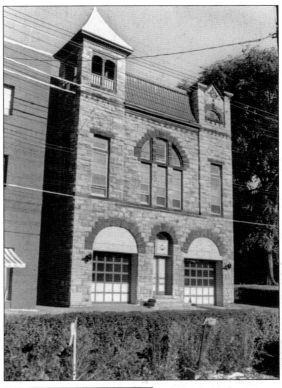

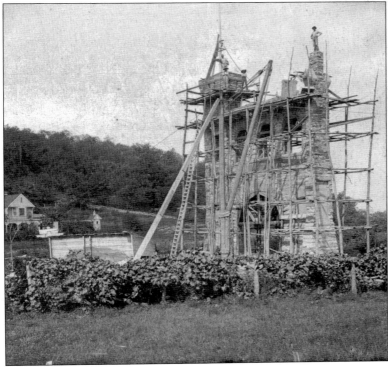

In 1896, George Alfred Townsend erected this monument to Civil War correspondents at Crampton's Gap in southern Washington County. The similarities between the Antietam fire hall and this monument are striking. It is believed that Townsend patterned his monument on the fire hall after witnessing its construction. (Courtesy of the First Hagerstown Hose Company.)

The first day on the job for Charles Flook Sr. was one to remember. On October 28, 1914, a fire consumed the Antietam Fire Company hall where the Pioneer Hook & Ladder Company was also housed. Flook was a driver for the Pioneers his entire career, retiring on May 28, 1952. (Courtesy of the First Hagerstown Hose Company.)

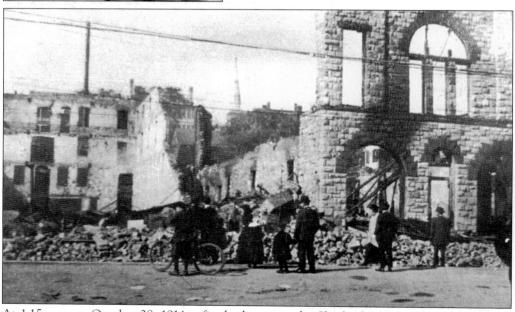

At 1:15 a.m. on October 28, 1914, a fire broke out at the Sherley building, which housed the Antietam Garage, Cumberland Valley Paper Box Company, and the Hippodrome Skating Rink in the 100 block of Summit Avenue, next door to the Antietam Fire Company. A man was lighting his auto's lights when vapors ignited a flash fire. He quickly ran next door to the firehouse, but the fire spread rapidly. (Courtesy of the First Hagerstown Hose Company.)

A crowd gathered to view the remains of the Antietam Fire Company. What does a fire department do when it needs help? The answer is call other fire departments. Hagerstown was assisted by fire departments from Chambersburg and Waynesboro, Pennsylvania, as well as Martinsburg, West Virginia. (Courtesy of the First Hagerstown Hose Company.)

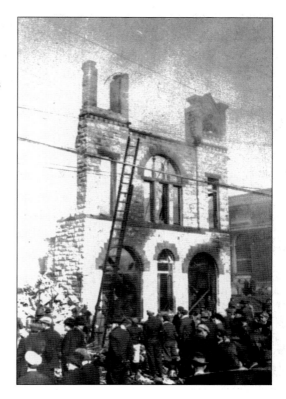

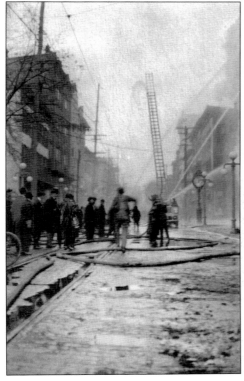

It is alleged that embers from the Summit Avenue fire started another fire at the Balwin Hotel in the unit block of West Washington Street, the current site of the University of Maryland campus. The Pioneer's 1914 American LaFrance ladder truck is pictured here dousing the flames. (Courtesy of the First Hagerstown Hose Company.)

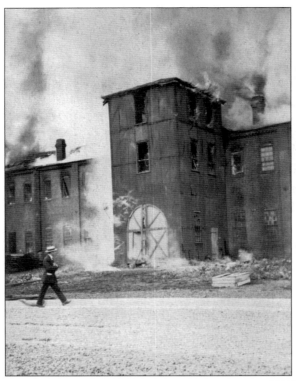

Over 5,000 people watched as fire gutted the Mantle and Furniture Company and the Duplex Brush Company on June 16, 1915. The brick structure was 180 feet long and 60 feet wide. The loss was in excess of $20,000. The building was owned by the Cumberland Valley Railroad. (Courtesy of the First Hagerstown Hose Company.)

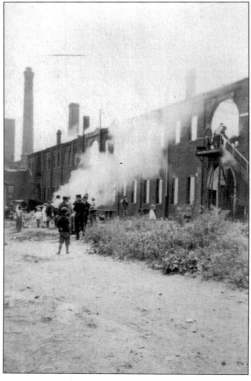

The Mantle and Furniture Company was on McPherson Street near Church Street. Two hose lines were attached to a hydrant at Foundry Street (Burhans Boulevard) and Salem Avenue. There was a constant pressure of 55 pounds from the water mains, but the biggest problem was not enough hydrants. Some were 1,100 feet apart. Several firefighters were injured, including Clarence Reichard of the Juniors, who had his thumb almost severed, and Ott Bowers, who was knocked down by a stream of water. (Courtesy of the First Hagerstown Hose Company.)

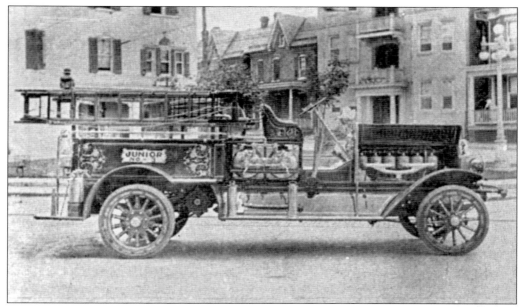

The Junior's first motorized apparatus was this 1915 Seagrave combination hose and chemical wagon. Ordered on February 25, 1915, it arrived four months later. The engine cylinders were open and the heads individually cast. (Courtesy of the Independent Junior Fire Company.)

In 1921, the chemical tanks were removed and a 500-gallon-per-minute centrifugal water pump was added. Centrifugal pumps became the standard on pumpers up to the present day. (Courtesy of the First Hagerstown Hose Company.)

When fire apparatus pulls onto the street, nearly everyone, especially children, stop to take a look. This is the Pioneer's 1914 American LaFrance aerial ladder truck pulling out of the Western Enterprise Fire Company. The power train consisted of a 72-horsepower gasoline engine with electrical assisted wheels. The aerial ladder was 75 feet long and was considered a quick-raise device. (Courtesy of the First Hagerstown Hose Company.)

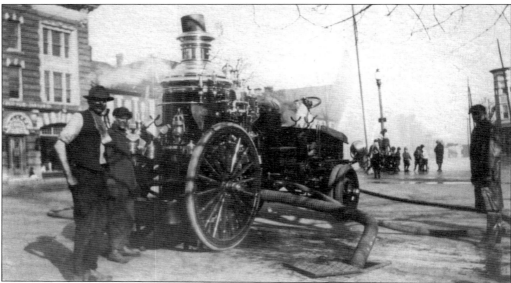

Pictured here is the Western Enterprise Fire Company's 1908 American LaFrance steam engine pumping from a cistern during a training exercise in Washington Square. The two-wheeled, six-cylinder tractor replaced the horses in 1917. The Enterprise's first steam engine was manufactured by James Smith of New York and was purchased in 1874 from the Fire Department of New York. (Courtesy of the Richard Smith collection.)

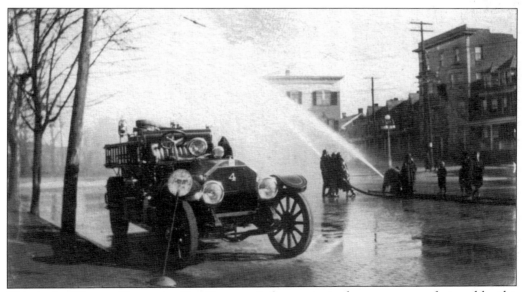

Hagerstown, Md., _April 22, 1918_

TO THE OFFICERS AND MEMBERS OF THE

Western Enterprise Fire Co., No. 4

I, _Howard M. Adams_____, do hereby make application to become a member of the **Western Enterprise Fire Company.** I am a resident of Hagerstown, and not a member of any other fire organization in the city.

Age _32_ Occupation _Boiler Maker_ Resident _Hagerstown Md._

I recommend this applicant _Russell Anderson_

Most applicants of this era were blue collar workers. Many worked for the local railroads. Common occupations included machinist, train dispatcher, conductor, locomotive painter, and brakeman. Others were carpenters, harness makers, and even several physicians. This application was signed by Russell "Peep Sight" Anderson, who was a driver from 1918 until the late 1950s. (Courtesy of the Western Enterprise Fire Company.)

This is the Western Enterprise Fire Company's first motorized pumper, manufactured by the American LaFrance Company. Like many vehicles of its day, this pumper had a right-hand drive. The photograph was taken in Washington Square. (Courtesy of the Richard Smith collection.)

No 13 S Potomac St., Hagerstown, Md.

R. M. HAYS & BROS

In 1898, a request was made to the trolley company to purchase hose bridges (ramps that protect the hose from being run over). With hose bridges the public would not be inconvenienced by trolley cars forced to stop for hoses laid for fighting fires. This postcard view shows the public square facing South Potomac Street. (Courtesy of the Washington County Historical Society.)

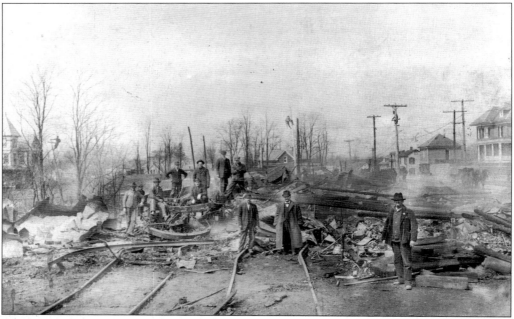

This was the trolley car barn at the intersection of Summit Avenue and Howard Street. The linemen atop the poles in the background are repairing damaged electric lines. The Emmanuel United Methodist Church now occupies the site. (Courtesy of the Washington County Historical Society.)

Two

FOX ON THE RUN
1920–1949

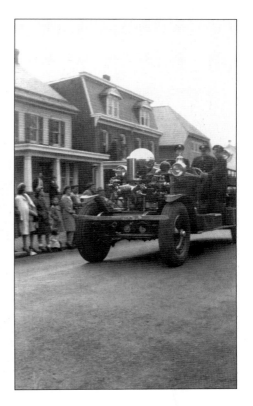

One of the powerhouse fire apparatus manufacturers in the first half of the 1900s was Ahrens-Fox. Shown here during a veterans parade on November 11, 1946, is the Hose Company's 1923 1,000-gallon-per-minute pumper known as "Dynamite." Hagerstown had four Ahrens-Fox pumpers and one ladder truck through the years. (Courtesy of the First Hagerstown Hose Company.)

Hagerstown Fire Alarm
Signals

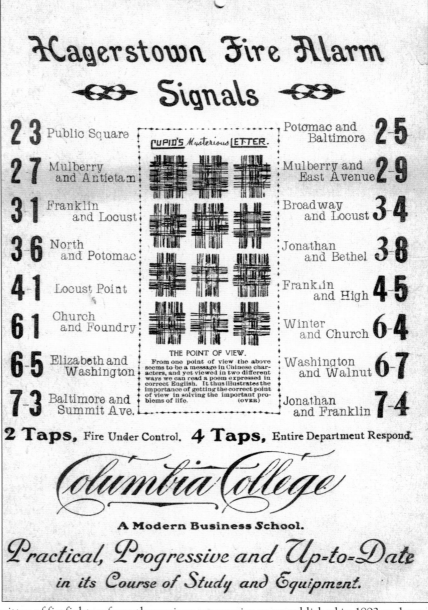

2 3 Public Square	**CUPID'S** *Mysterious* **LETTER.**	Potomac and Baltimore **2-5**
2 7 Mulberry and Antietam		Mulberry and East Avenue **2 9**
3 1 Franklin and Locust		Broadway and Locust **3 4**
3 6 North and Potomac		Jonathan and Bethel **3 8**
4 1 Locust Point		Franklin and High **4-5**
6 1 Church and Foundry		Winter and Church **6 4**
6-5 Elizabeth and Washington		Washington and Walnut **6-7**
7-3 Baltimore and Summit Ave.		Jonathan and Franklin **7-4**

THE POINT OF VIEW.

From one point of view the above seems to be a message in Chinese characters, and yet viewed in two different ways we can read a poem expressed in correct English. It thus illustrates the importance of getting the correct point of view in solving the important problems of life. (OVER)

2 Taps, Fire Under Control. **4 Taps,** Entire Department Respond.

Columbia College

A Modern Business School.

Practical, Progressive and Up-to-Date in its Course of Study and Equipment.

A committee of firefighters from the various companies was established in 1893 to determine the feasibility of installing a fire alarm system. In 1894, an act by the state legislature authorized the mayor and council to issue bonds in the amount of $3,000 for the establishment of a fire alarm system. The proposal received a large majority vote from citizens in the March election. The alarm system was installed by the Gamewell Fire Alarm Telegraph Company of New York, the most recognized name in fire alarm systems, and was in operation by 1895. It was first thought that the town bell could sound the alarm, but it was determined to be too small. A larger bell was purchased for $547 and installed in the tower of city hall. Firefighters counted the number of bell taps to determine the location of the fire. (Courtesy of the First Hagerstown Hose Company.)

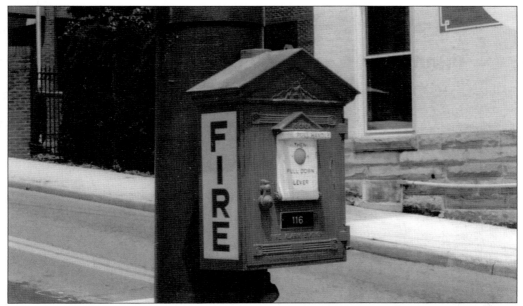

This is a 1931-design street box at the intersection of Antietam Street and Summit Avenue. Due to the advent of cell phones and the cost of maintaining the system, a majority of the boxes were removed in 2004. By the end of 2005, the system will be completely out of service. The Gamewell system provided a quick, reliable means for citizens to summon the fire department. (Courtesy of the William Dieterich collection.)

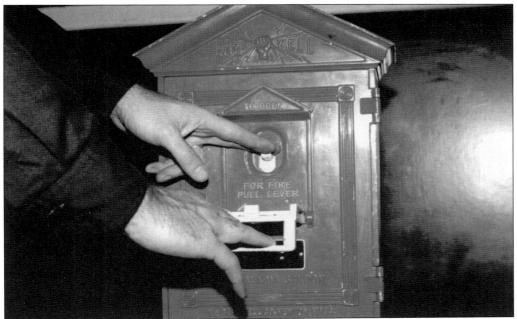

Early Gamewell boxes required a key to activate the alarm. Police officers, business owners, and respected citizens living close to a fire box had keys. Since this could cause a delay, later fire boxes such as this were designed to be activated by anyone. Instructions are printed on the fire box. (Courtesy of the First Hagerstown Hose Company.)

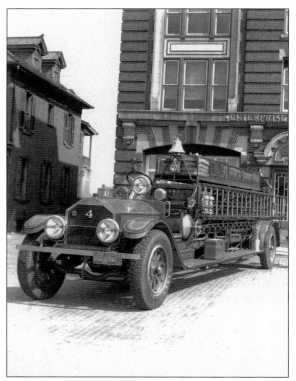

This 1920 American LaFrance ladder truck was the Western Enterprise Fire Company's first ladder truck. It was considered a city service truck because of the omission of an aerial ladder. The power train consisted of a 6-cylinder, 73-horsepower motor. Equipment included nine wooden ladders totaling 235 feet and a 45-gallon chemical tank (large fire extinguisher). (Courtesy of the Washington County Historical Society.)

These men were members of the 1938 Western Enterprise softball team. Players were required to be members of the fire company. Pictured from left to right are (first row) Jim Dixon, Casey Martin, and two unidentified men; (second row) Charlie Socks, Clinton "Fats" Lapole, Charles "Ticker" Athey, Dick Messersmith, Al Berger, and unidentified. (Courtesy of the Western Enterprise Fire Company.)

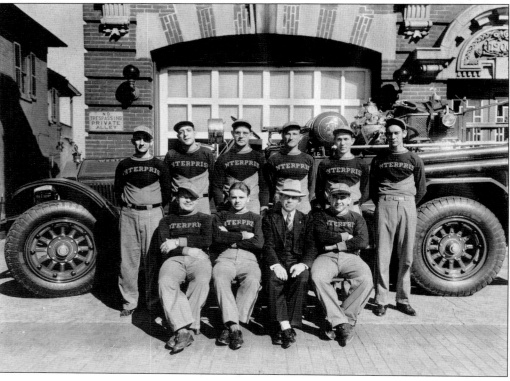

These prominent Hagerstown firefighters are on "Dynamite," model NS-4 (reg. no. 937). Dynamite was Hagerstown's first Ahrens-Fox pumper. Pictured from left to right are an unidentified child, Ed Beckley, Driver Preston Smith, Driver A. K. McGraw, Ed Kerton, two unidentified men, and Driver Frank Maisack. (Courtesy of the First Hagerstown Hose Company.)

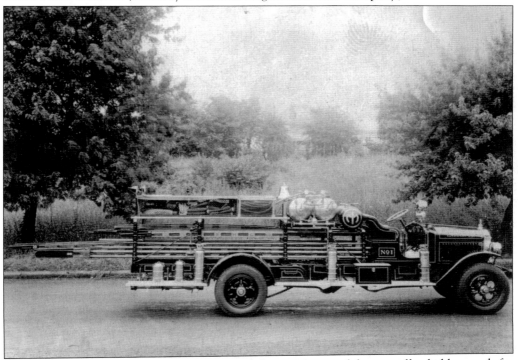

The membership of the Pioneers determined there was a need for a smaller ladder truck for response to suburban alarms to save the larger 1914 American LaFrance ladder truck for use in the business district. This 1927 Mack city service truck, known as the "Chimney Chaser," arrived in May of 1927. (Courtesy of the Harry Daveler collection.)

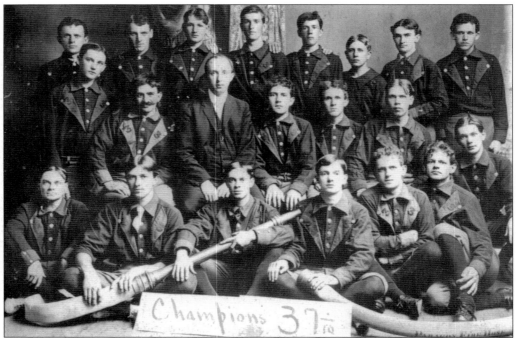

This is the Junior's championship hose reel team. Pictured from left to right are (first row) Harry Kershner, John Wolf, Roy Widdows, William Garling, Cliff Betts, Richard Dornberger, and Guy Kemp; (second row) Burt Miller, Harry "Doc" Ash, Clarence Hose, Robert Hose, and Spence Saylor; (third row) Owen Hartle, Sam Artz, Bruce Snyder, Howard Harne, O. Jacobs, Charles Shaffner, Frank Carpenter, John Talbert, and Lester Snyder. (Courtesy of the author.)

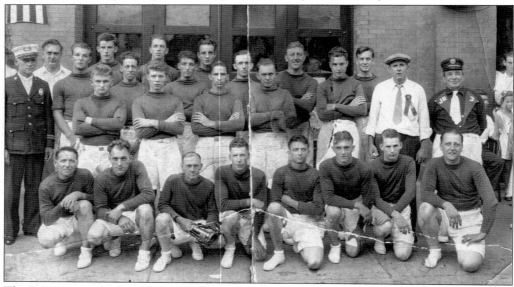

The Juniors won the Cumberland Valley Volunteer Firemen's Association reel race in 1934 with a time of 40 seconds. A reel race consisted of 17–20 men pulling a reel with 250 feet of hose. Contestants would attach and lay one line of hose 150 feet from a hydrant, uncouple the hose and attach a nozzle, then drop the nozzle within 25 feet of the finish line. (Courtesy of the author.)

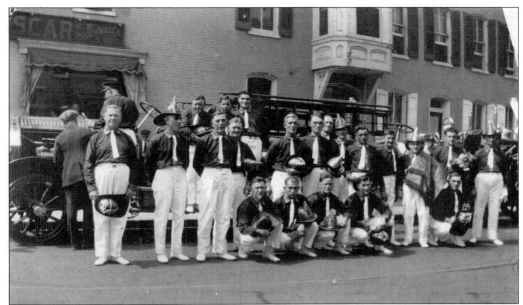

In the 1800s and the first half of the 1900s, firefighters often attended parades in neighboring cities. The Hagerstown Fire Department hosted its own Thanksgiving Day parade as well as attending others, including the Cumberland Valley Volunteer Firemen's Association, the Maryland State Firemen's Association, Christmas, and Veterans Day parades. The Junior's firefighters are pictured wearing elaborate uniforms preparing for a festive event. (Courtesy of the First Hagerstown Hose Company.)

In this photograph, Junior firefighter Charles Boward proudly wears his parade uniform. The photograph was taken in April 1942. He became a volunteer in 1940. When not fighting fires, he worked as a mason, plumber, and security guard. Boward really enjoyed spending time at the firehouse. (Courtesy of the Independent Junior Fire Company.)

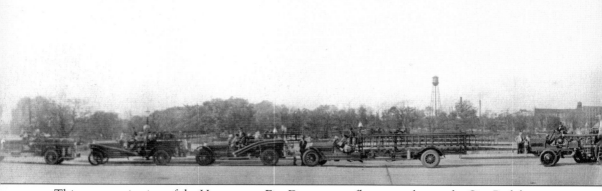

This panoramic view of the Hagerstown Fire Department fleet was taken at the City Park between 1927 and 1930. From left to right are the First Hagerstown Hose Company's 1923 Ahrens-Fox pumper "Dynamite" and its 1911 Robinson pumper; the Western Enterprise Fire Company's 1925 American LaFrance pumper "Maude," 1920 American LaFrance city service ladder truck, and 1908 American LaFrance steam engine with motorized tractor; the Independent Junior Fire

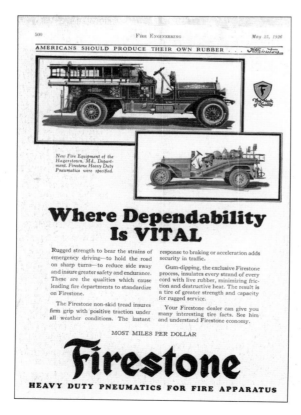

This Firestone Tire advertisement highlights two Hagerstown fire pumpers. The Junior's rebuilt 1915 pumper and the Western Enterprise's 1925 pumper. The ad appeared in *Fire Engineering* magazine. (Courtesy of the author.)

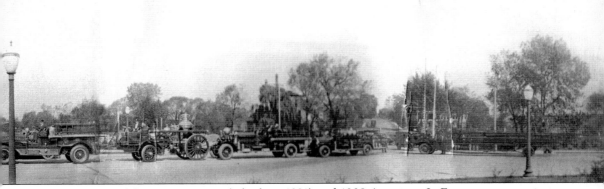

Company's 1915 Seagrave pumper (rebuilt in 1921) and 1908 American LaFrance steam engine with a Seagrave motorized tractor; the Antietam Fire Company's 1924 Ahrens-Fox pumper; and the Pioneer Hook & Ladder Company's 1927 Mack city service ladder truck "Chimney Chaser" and 1914 American LaFrance ladder truck. (Courtesy of the Pioneer Hook & Ladder Company.)

This is an advertisement for the Ahrens-Fox Fire Apparatus Company. This letter of satisfaction with Ahrens-Fox pumpers was sent by the Hose Company's foreman, D. E. Beckley. The Hose Company still owns this 1946 Ahrens-Fox pumper known as "Slugger." (Courtesy of the author.)

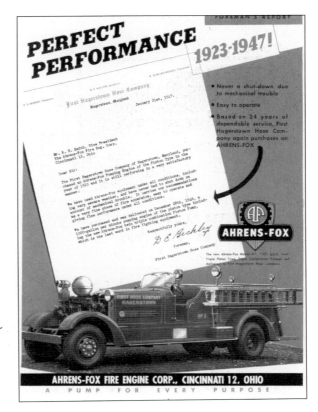

George Basore transferred from the police department to the fire department in 1941. Driver Basore continued a family tradition: his father and brother were police officers and his grandfather Harry Borne was a driver at Western Enterprise. Basore worked for the Junior Fire Company. His first fire as a driver was in the Scott building on West Washington Street on June 24, 1941. (Courtesy of the author.)

Sitting in front of the firehouse is the Junior's 1931 Seagrave 1,000-gallon-per-minute pumper known as "Barkin Bertha." There was no windshield on this pumper. During the winter, it was not uncommon for the drivers to be covered with ice upon arrival at a fire. The pumper was a right-hand drive and was hard to stop because of the two-wheel mechanical brakes. (Courtesy of the Washington County Historical Society.)

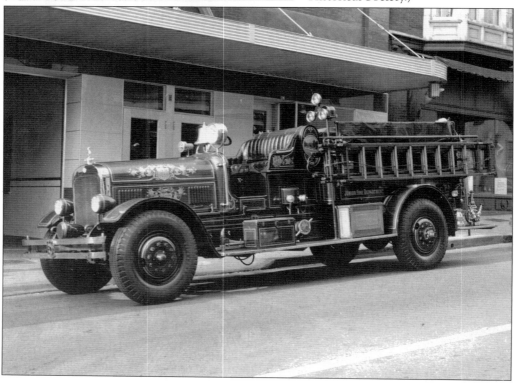

Chester "Polly" Lohr worked as a driver for the Pioneer Hook & Ladder Company. Pioneer drivers began receiving a salary in 1897. The executive committee was responsible for establishing work hours, rules, and housekeeping duties such as taking care of the horses and cleaning the truck and room each day. (Courtesy of the First Hagerstown Hose Company.)

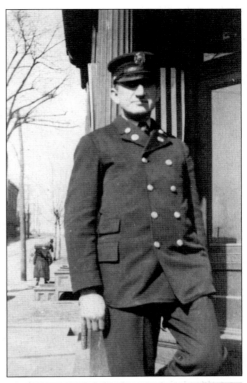

The South Hagerstown Fire Company formed in about 1932 at the intersection of First Street and Guilford Avenue. Pictured is the groundbreaking ceremony. Only the basement, or social hall, was finished originally. The social hall held fund-raising activities as well as carnivals in front of the hall on Guilford Avenue. In the early 1930s, lightning struck the roof of the foundation, causing moderate damage. The apparatus bay was not finished until 1950. (Courtesy of the Washington County Historical Society.)

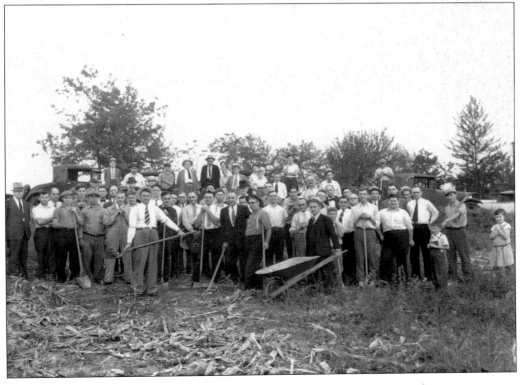

Smoke is still emitting from the Odd Fellows Temple in the 100 Block of South Potomac Street on the morning after the building was consumed by flames. At 1:50 a.m. on February 12, 1939, box alarm 22 was sounded over the Gamewell fire alarm system alerting firefighters to the blaze. Assistance was also provided by the Funkstown and Williamsport Fire Companies, who arrived in just 13 minutes. (Courtesy of the Washington County Free Library, Western Maryland Room.)

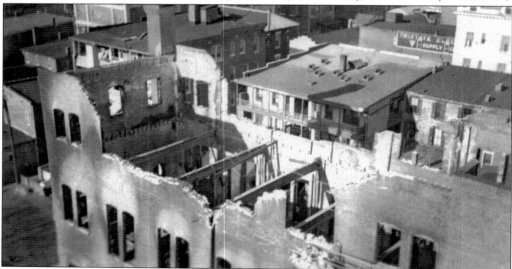

The Odd Fellows fire was one of the hottest fires in memory according to some firefighters. At one point 6,000 gallons of water per minute were pouring onto the flames. An estimated 20,000 people witnessed the spectacle. The damages were estimated at $125,000. (Courtesy of the Washington County Free Library, Western Maryland Room.)

When Antietam Fire Company driver John Bomberger awoke to the clang of the fire bell, there was no mistaking the fire's location. He could see the flames from the Odd Fellows Temple from his bunkroom window. Bomberger said, "We are going to work tonight." At the time of the Odd Fellows fire, Driver Bomberger was in his 33rd year of service with the Antietam Fire Company. (Courtesy of the William Dieterich collection.)

The Pioneer's 1930 Ahrens-Fox ladder truck responded to the Odd Fellows Temple fire. The truck was known as the "85" because that was the length of its aerial. The truck carried 11 ground ladders including 40-foot and 50 foot extension ladders. About 10 to 12 feet of ladder protruded from the rear of the truck. (Courtesy of the First Hagerstown Hose Company.)

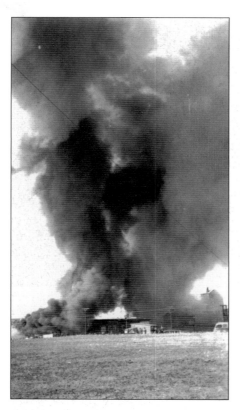

On February 12, 1943, a spectacular fire swept through the fertilizer and spray materials plant of the Central Chemical Company on Mitchell Avenue. The fire struck during the peak production season. This was one of many fires through the years at the plant. Initially firefighters faced inadequate water pressure from the nearest hydrant, which was 1,200 feet away. (Courtesy of the Washington County Free Library, Western Maryland Room.)

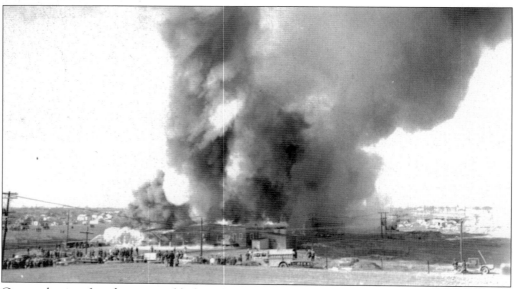

Great columns of smoke were visible for miles against cloudless skies. The north end of Hagerstown was covered in thick black smoke from the Central Chemical Company fire. It was the most spectacular since the Odd Fellows Temple fire in 1939. (Courtesy of the Washington County Free Library, Western Maryland Room.)

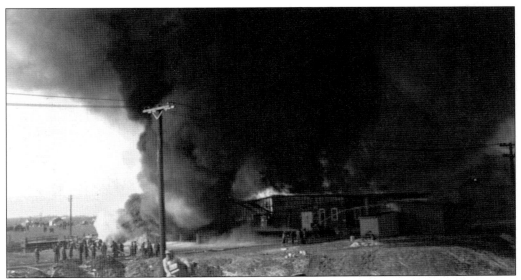

This is another view of the Central Chemical fire. Several explosions of chemicals shook the burning building. Hagerstown police chief William H. Peters and the Maryland State Police assisted with crowd control. (Courtesy of the Washington County Free Library, Western Maryland Room.)

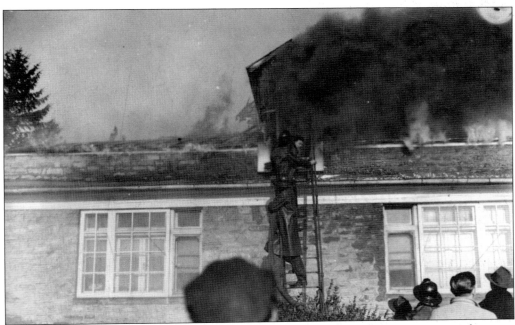

All 45 residents of the Hillcrest Convalescent Home on Northern Avenue escaped serious injury when fire struck on December 14, 1946. Training during World War II aided the nursing staff and firefighters in their quick evacuation of residents. The building was originally the Hagerstown Country Club. It is now the home of the American Legion. (Courtesy of the William Dieterich collection.)

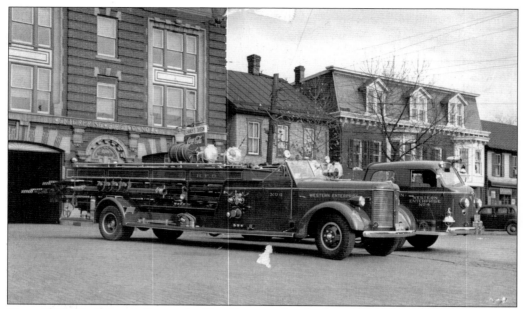

Since 1920, the Western Enterprise Fire Company has had a pumper and a ladder truck. This is the only fire company that permanently shares two different types of apparatus. Displayed in front of the Enterprise firehouse are the 1939 American LaFrance city service truck known as the "Lumber Pile" (because of all of the wooden ladders it carries) and the 1948 American LaFrance pumper. (Courtesy of the Henry DeLauney collection.)

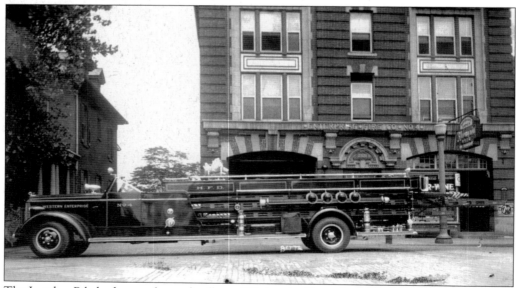

The Lumber Pile had a very long wheelbase. When asked how the drivers maneuvered the truck through the narrow West End streets, Driver William Hovermill joked, "You just have to bend it in the middle a little." The Lumber Pile was an American LaFrance 500 series, type 945 open cab model. (Courtesy of the Henry DeLauney collection.)

The variety of work provided the lure and kept George E. Paulsgrove interested in his job. Paulsgrove was five feet, five inches tall and weighed 133 pounds. His career as a driver at the Pioneer Hook & Ladder Company began on June 15, 1915. (Courtesy of the First Hagerstown Hose Company.)

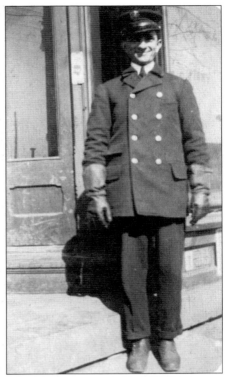

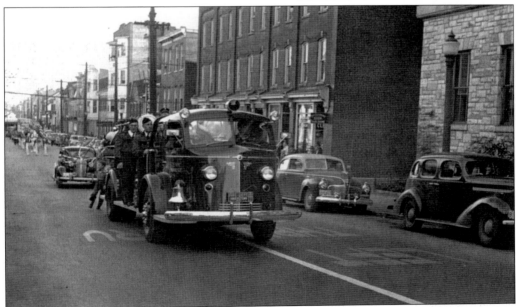

This is the Western Enterprise's 1948 American LaFrance 700 series pumper. It was the first enclosed-cab fire apparatus in Hagerstown and offered a 1,500-gallon-per-minute pump for use at the West End reservoir if necessary. The pump panel was on the right side. It is shown here with veterans aboard in the Veterans Day parade on November 11, 1946. (Courtesy of the William Dieterich collection.)

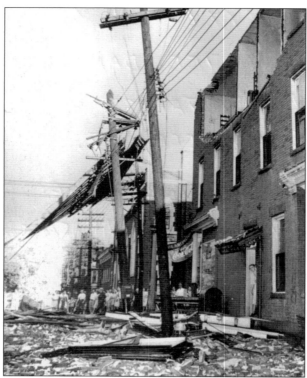

The fire department responds not only to fires but also to natural disasters. On June 8, 1947, a tornado ripped through Washington County. In Hagerstown, the twister struck especially hard near City Park, but all portions of the city were affected. This was the devastation at Antietam and Mulberry Streets. (Courtesy of the William Dieterich collection.)

Resources are stretched thin when a storm strikes and dozens of emergency calls are received within a short time. This house in the 100 block of North Mulberry Street received heavy damage. Notice the person looking out of the window. (Courtesy of the William Dieterich collection.)

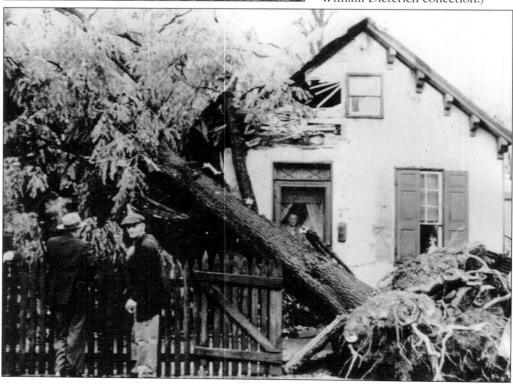

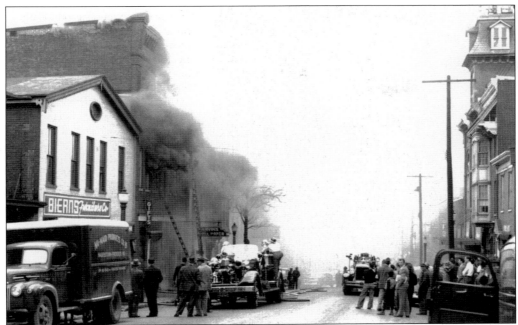

A three-alarm fire struck the old S. M. Bloom warehouse in the 100 block of North Potomac Street shortly after noon on March 24, 1948. The smoke was so thick that several spectators were transported to the hospital by the Minnich ambulance. (Courtesy of the First Hagerstown Hose Company.)

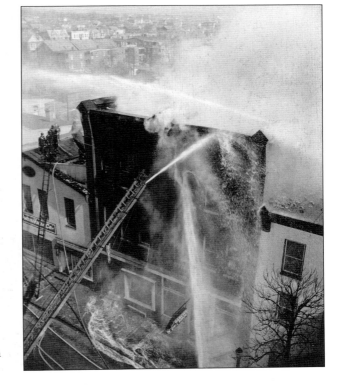

Twenty fire streams attacked from the exterior at the S. M. Bloom fire. Fourteen apartments, a gift shop, and a wallpaper store were destroyed. Damage estimates totaled $100,000. Firefighters contained the blaze to only one building. (Courtesy of the William Dieterich collection.)

49

In the post–World War II era, new pumpers were purchased for each fire company in Hagerstown. This is the Junior's 1947 Seagrave pumper. The pump could flow 1,000 gallons per minute, and a 150-gallon water tank was onboard. It carried 1,200 feet of two-and-one-half-inch hose, 500 feet of one-and-one-half-inch hose, and 300 feet of three-quarter-inch booster hose. (Courtesy of the First Hagerstown Hose Company.)

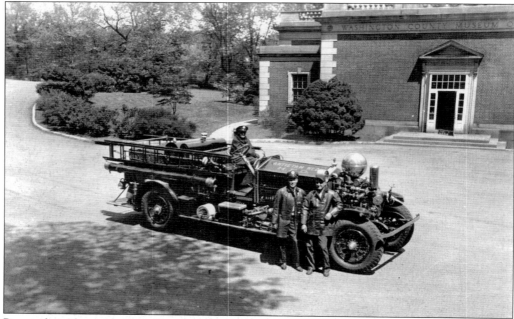

Pictured are three Antietam Fire Company drivers. From left to right are John Bomberger, Kenny Myers, and Ralph Foltz. The pumper is the Antietam's 1924 Ahrens-Fox Model NS-4 (reg. no. 1609). It contained a 1,000-gallon-per-minute piston pump and a 60-gallon water tank. (Courtesy of the William Dieterich collection.)

Charles "Possum" Harrison started as a driver for the Antietam Fire Company when motorized equipment was unknown and horses pulled the apparatus. Driver Harrison worked really well with the horses. Prior to joining the fire department, he learned the tinner's trade. His service to Hagerstown spanned the decades from 1899 to 1941. (Courtesy of the Antietam Fire Company.)

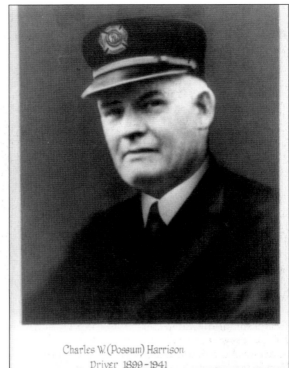

Charles W. (Possum) Harrison
Driver 1899-1941

The Antietam Fire Company placed its second Ahrens-Fox Model HT (reg. no. 3468) pumper in service in 1948. It has a 1,000-gallon-per-minute piston pump and a 150-gallon water tank. The pumper is currently owed by Irving Jensen in Sioux City, Iowa. (Courtesy of the Henry DeLauney collection.)

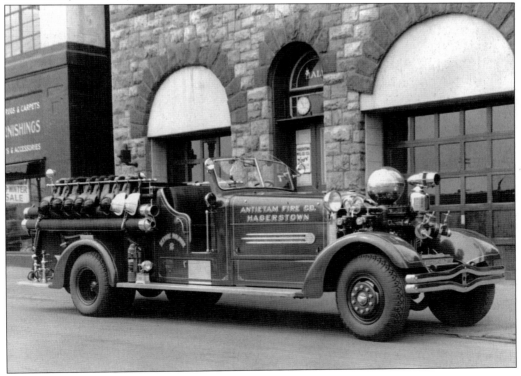

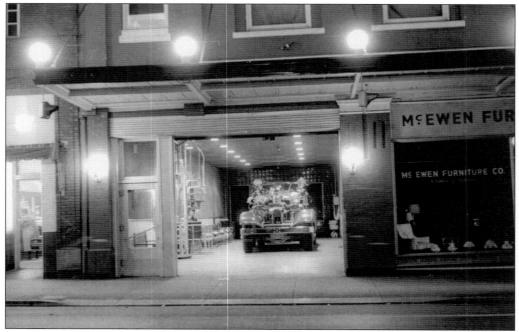

The Hose Company's 1946 Ahrens-Fox Model HT (reg. no. 3459) pumper known as "Slugger" is pictured in the firehouse, ready for a call. The Hose Company has called this firehouse home since 1881. The McEwen Furniture Company on the right provided rental income for the Hose Company. (Courtesy of the First Hagerstown Hose Company.)

This young man is learning the trade of a firefighter at a very early age. He is using a soda acid type fire extinguisher. When the extinguisher was inverted, a small bottle of acid mixed with a combination of water and baking soda, forming carbon dioxide gas, which propelled the soda water onto the fire. (Courtesy of the First Hagerstown Hose Company.)

Three

CHIEF HALL
TAKES COMMAND
1950–1969

Chief John Hall took the reigns of leadership in the Hagerstown Fire Department after the death of his mentor, Chief Max Hoover, in 1952. Chief Hall was nominated for the position by representatives of the six Hagerstown fire companies. Final approval came from Mayor Mills and the city council. (Courtesy of the First Hagerstown Hose Company.)

Chief Max Hoover's service to Hagerstown began as a volunteer in about 1911 with the Independent Junior Fire Company. Chief Hoover became the volunteer fire chief in 1932. In 1948, he became Hagerstown's first paid chief. Hoover is pictured here standing next to the chief's car, a Studebaker. Before there was a chief's car, a taxi was at the chief's disposal. (Courtesy of the Henry DeLauney collection.)

Chief Hall is pictured beside his 1951 Chevrolet chief's car. Hall served in the U.S. Navy from 1943 to 1945. Upon his discharge, he went to work for Fairchild Aircraft as a firefighter, and in 1950, he was hired as a driver at the Pioneer Hook & Ladder Company. (Courtesy of the First Hagerstown Hose Company.)

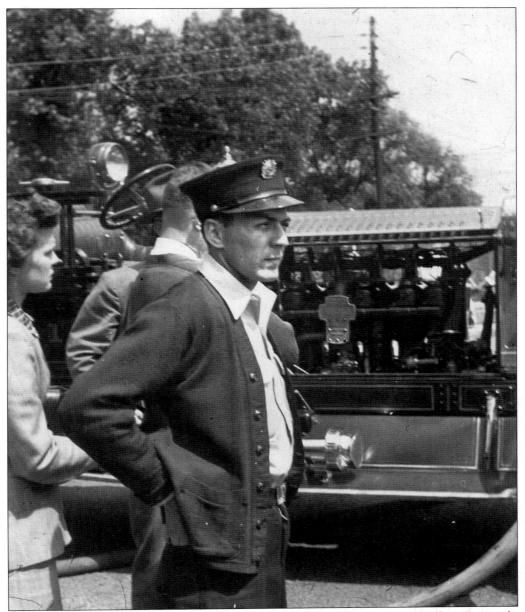

Next to the word "firefighter" in Hagerstown dictionaries should be the name William Dieterich. Bill's true love and devotion to the fire service is evident in his words and actions. Dieterich's firefighting journey began in 1942 as a volunteer at the Antietam Fire Company. In 1950, he became the first driver for the new South Hagerstown Fire Company. The first alarm for South Hagerstown was a small outside fire near the Hagerstown Lumber Company off Commonwealth Avenue. In 1954, he was appointed to the new position of relief driver, which rotated to different firehouses. In 1957, he became the regular driver at the Western Enterprise Fire Company. He transferred to the Hagerstown Signal Department in 1959. He retired from Hagerstown in 1987 but remains a dedicated volunteer and historian at the South Hagerstown Fire Company. (Courtesy of the William Dieterich collection.)

Robert Parks and George Coleman are pictured in front of the new South Hagerstown Fire Company on the warm summer afternoon of June 18, 1950. (Courtesy of the William Dieterich collection.)

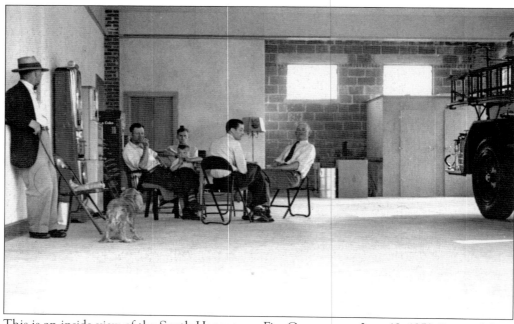

This is an inside view of the South Hagerstown Fire Company on June 18, 1950. Pictured from left to right are Mr. Hagerman, John Fisher, Driver Jim McMahan (driver at South Hagerstown from 1950 to 1953), an unidentified child, Guy Boward, and Ed Koogle (trolley car motorman). (Courtesy of the William Dieterich collection.)

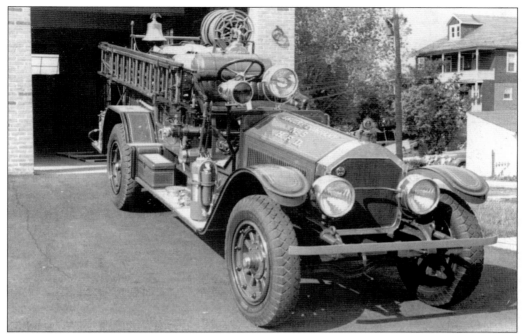

South Hagerstown's first pumper was this 1925 American LaFrance known as "Maude." This pumper was originally housed at the Western Enterprise Fire Company. Maude had a 750-gallon-per-minute pump and a 100-gallon water tank. Equipment included 1,000 feet of two-and-one-half inch hose and 250 feet of booster hose. (Courtesy of the William Dieterich collection.)

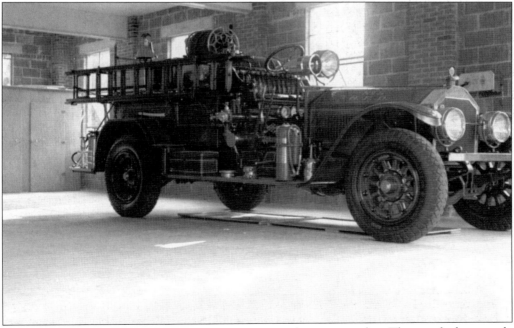

This is the 1925 American LaFrance pumper sitting in the apparatus bay. The new firehouse only provided the basic necessities. (Courtesy of the William Dieterich collection.)

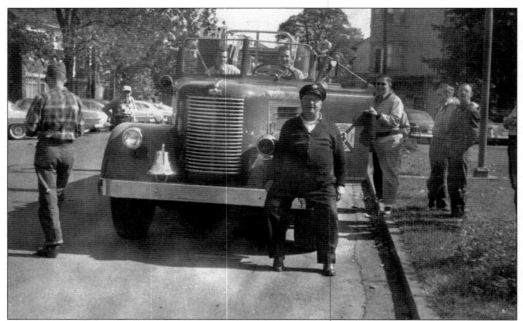

Several firefighters pose for a photograph with the Western Enterprise's new ladder truck, a 1956 Pirsch known as "Bruno." Pictured from left to right are two unidentified men, Ronnie Lushbaugh (in cab), Henry DeLauney (in cab), Driver Russell "Peepsight" Anderson (on bumper), Billy Palmer, Bob Hall, and Junior Baker. (Courtesy of the William Dieterich collection.)

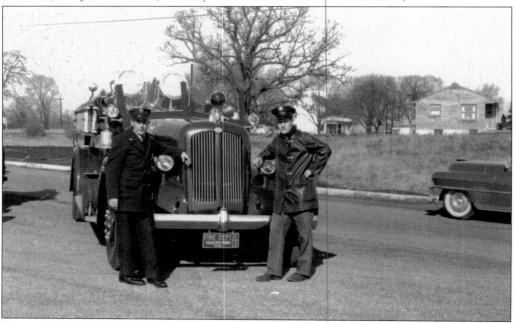

Pictured standing in front of the Junior's 1947 Seagrave pumper are William Dieterich (left) and Benjamin Conrad (right). Hired on August 1, 1951, FAO Conrad worked all of his 32-year career at the Independent Junior Fire Company. His last day of service was March 19, 1984. (Courtesy of the William Dieterich collection.)

Drivers A. K. McGraw (left) and Fred "Prunie" Wellinger (right) share a lighthearted moment. Driver Wellinger drove the pumper at Western Enterprise for 40 years, retiring in May 1957. He was a veteran of World War I and served as a volunteer at Western Enterprise prior to becoming a driver. (Courtesy of the William Dieterich collection.)

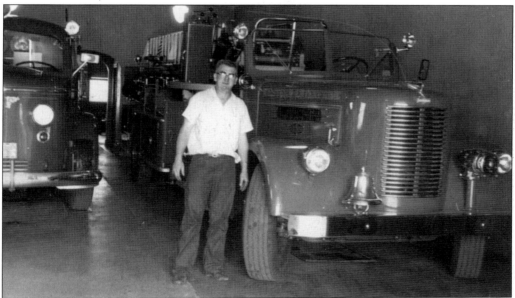

William Hovermill drove the ladder truck at Western Enterprise from the late 1930s until the late 1960s. Prior to becoming a driver, he served as a volunteer at Western Enterprise. Behind Driver Hovermill are the Enterprise's 1948 American LaFrance pumper and 1956 Pirsch ladder truck. Space was limited. Both pieces of apparatus shared the same bay door. (Courtesy of the William Dieterich collection.)

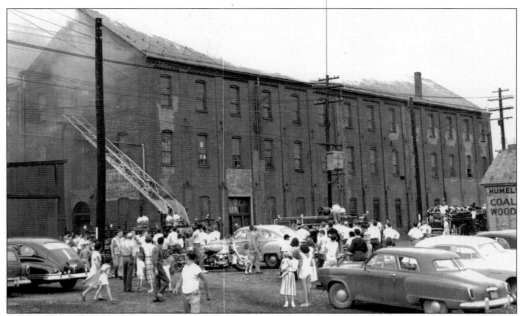

Firefighters of the Pioneer Hook & Ladder Company are raising the aerial at a fire at Maryland Metals in the 200 block of Church Street during the summer of 1954. Smoke is emitting from the upper floors. This photograph was snapped shortly after the arrival of the fire department. (Courtesy of the Washington County Free Library, Western Maryland Room.)

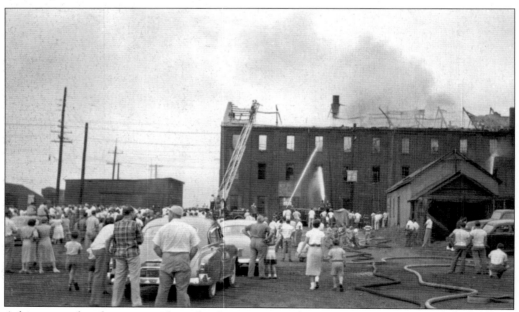

A large crowd gathers to watch as the fire consumes the upper floors of the Maryland Metals building. It is believed that stored magnesium contributed to the rapid spread of the fire. (Courtesy of the John Hall collection.)

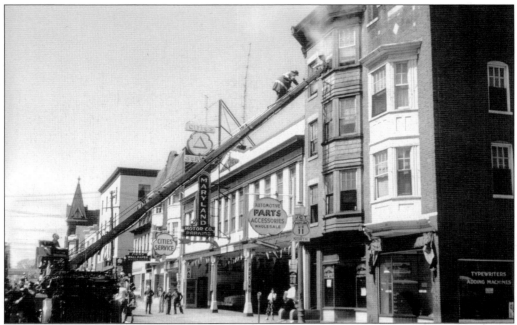

The Pioneer's 1930 Ahrens-Fox ladder truck is raised to an apartment fire in the unit block of West Franklin Street in 1958. The aerial did not have side rails for firefighters to grab onto, only rungs. In the background is the Maryland Motors Company, which is now the site of the post office. (Courtesy of the First Hagerstown Hose Company.)

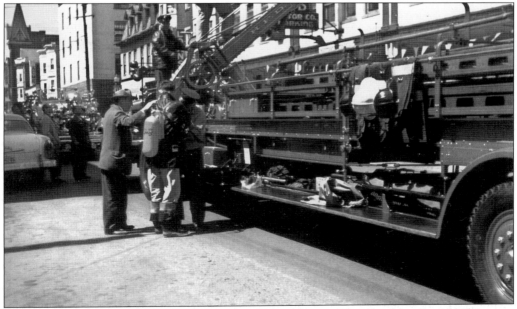

This is another view of the 1958 apartment building fire on West Franklin Street. This must have been an embarrassing moment for the firefighter attempting to put on the air pack, as he has it on upside down. Nevertheless, others are trying to help hook it up for him. (Courtesy of the First Hagerstown Hose Company.)

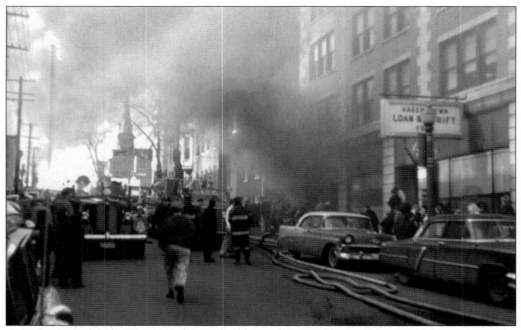

A fire broke out in the Turner Coliseum building in the 100 block of West Washington Street on January 31, 1959. The two-alarm blaze brought out all six fire companies. The building contained a restaurant, bowling alley, and offices. Firefighter Charles Baker was knocked to the ground by a falling sofa but escaped serious injury. (Courtesy of the First Hagerstown Hose Company.)

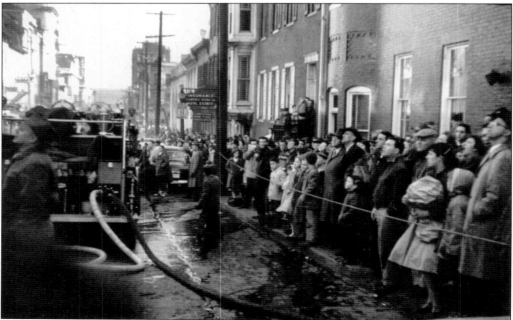

Large crowds are kept back at the scene of the 1959 Turner Coliseum fire. The fire started in a children's play area and spread quickly. Chief Hall praised the actions of the firefighters who put out the blaze. (Courtesy of the First Hagerstown Hose Company.)

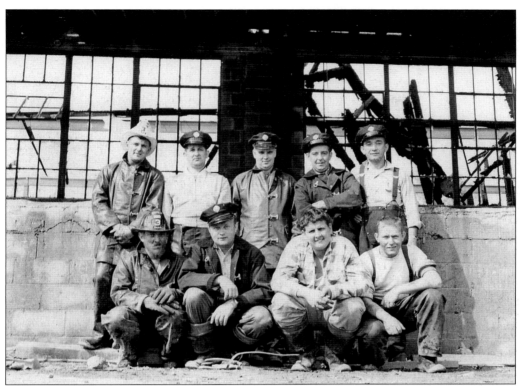

Behind these firefighters are the remains of the Federal Silk Mill in Williamsport. Hagerstown was called to assist with the 2:00 a.m. fire. Pictured from left to right are (first row) Pete Skelton, Driver Charles Garrett, Jack Green, and Moe Mazzingo; (second row) Drivers William Kershner, Henry DeLauney, Harry Daveler, William Karn, and Lawrence "Bud" Gabe. (Courtesy of the William Kershner collection.)

Every fire company within Hagerstown has an officer elected by the membership who is responsible for his/her members at fires. In the 1900s, titles such as chief, chief director, foreman, and captain were used. This is the Junior's chief Pete Skelton working at the Silk Mill fire on October 13, 1959. (Courtesy of the William Kershner collection.)

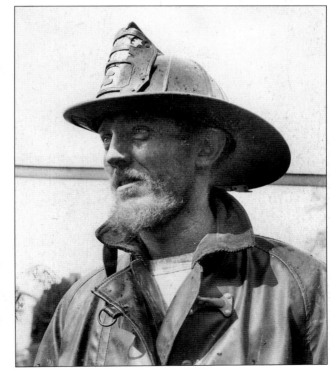

One unique innovation to teach children about the fire department was the use of school television. Each lesson discussed a different topic. Driver A. K. McGraw was the lead instructor. Notice the early model cameras. (Courtesy of the Tom Brown collection.)

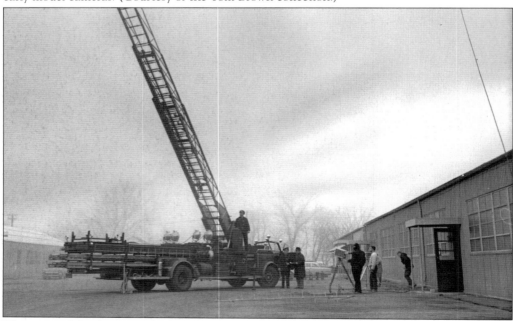

The topic of this lesson is the function of a ladder truck. The fly section of the Pioneer's 1948 American LaFrance ladder truck is being extended. Pictured from left to right are Driver William Karn, Driver A. K. McGraw, Mr. McElrath (instructor), Mr. Nalley, Mr. Newman, Mr. George, and Mr. Sullivan. (Courtesy of the First Hagerstown Hose Company.)

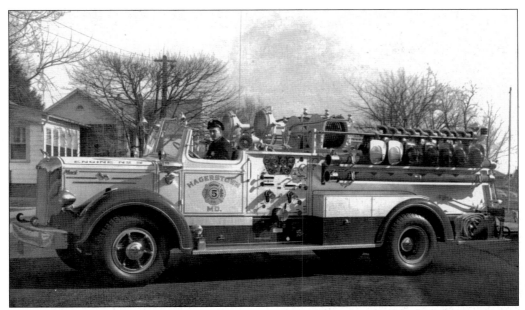

This 1952 Mack Model L85 pumper was the first engine in Hagerstown to install a mobile radio. The radio equipment was purchased under the civil defense program in 1953. The man behind the wheel is South Hagerstown driver Richard Trovinger. Most of Driver Trovinger's 31-year career was spent at the South Hagerstown firehouse. Driver Trovinger retired in 1983. (Courtesy of the Henry DeLauney collection.)

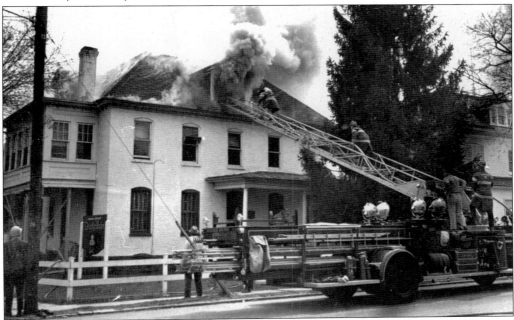

Attic fires are some of the most difficult to fight since access is often limited or non-existent. Often the ceiling and insulation must be pulled down with pike poles. Firefighters are attacking this stubborn attic fire at Virginia Avenue and Howard Street with the Pioneer's 1948 American LaFrance ladder truck. (Courtesy of the Richard Smith collection.)

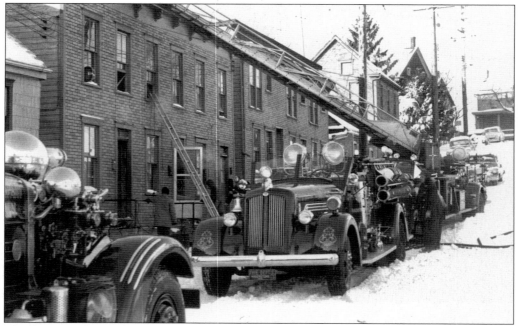

This was one of a series of fires that struck Hagerstown in a 24-hour period on December 13, 1960. The fire occurred in the 300 block of Liberty Street. The Junior's 1947 Seagrave pumper and the Pioneer's 1948 ladder truck are in front of the building. (Copyright *The Herald-Mail* Company, Hagerstown, Maryland.)

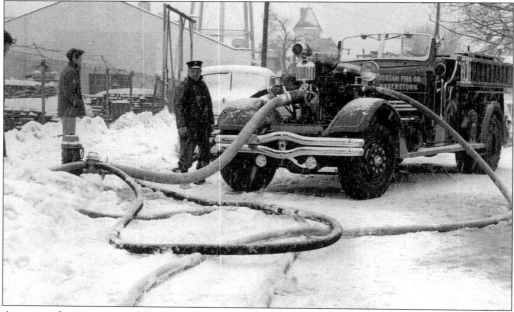

A serious fire was averted because of the prompt response of the fire department to the Victor Products building on Pope Avenue. The fire originated in the dust collector near the lumber finishing shop. The Antietam's 1948 Ahrens-Fox pumper driven by Ralph Foltz is seeing some action. (Courtesy of the First Hagerstown Hose Company.)

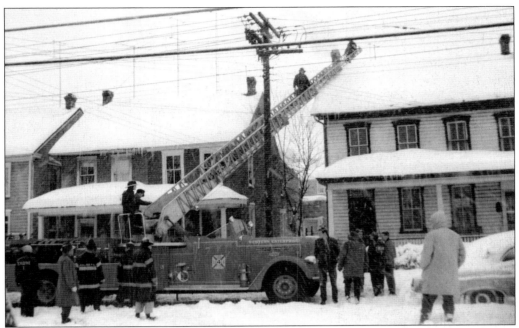

The fire department must respond to fires in all types of inclement weather. Snow storms can be one of the worst. This storm in February 1961 dumped 12 to 15 inches of snow on Hagerstown. The Western Enterprise's 1956 ladder truck "Bruno" has its ladder raised to the roof. (Courtesy of the First Hagerstown Hose Company.)

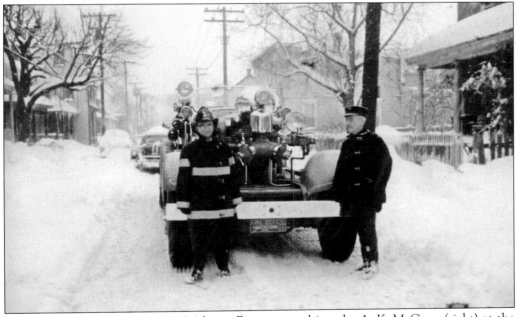

This is the Hose Company's 1946 Ahrens-Fox pumper driven by A. K. McGraw (right) at the scene of a fire during the same snow storm in 1961. Snow drifts as high as 10 feet were reported in some areas. The combination of snow, cold, and wind creates serious obstacles for firefighters. (Courtesy of the First Hagerstown Hose Company.)

Firefighters from the Pioneer Hook & Ladder Company are riding on the running boards of their new 1959 Pirsch ladder truck during a Christmas parade in November 1959. The photograph was taken in the unit block of South Potomac Street. (Courtesy of the First Hagerstown Hose Company.)

This is a close-up view of the Pioneer firefighters in the 1959 parade. The driver is Herman Negley. Driver Negley replaced his father, William, at the Pioneer Hook & Ladder Company after William was struck and killed by a car at the intersection of Potomac and Franklin Streets on September 18, 1930, while on duty. (Courtesy of the First Hagerstown Hose Company.)

The pump on the Hose Company's 1923 Ahrens-Fox shines during a Maryland State Firemen's parade on June 29, 1962. The photograph was taken in the 100 block of North Potomac Street. (Courtesy of the First Hagerstown Hose Company.)

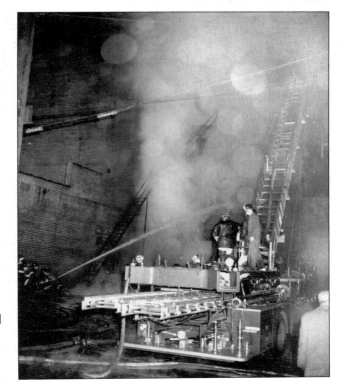

Smoke and rain hampered firefighting efforts at the Devon hotel, Alhambra tavern, and Sam's restaurant fire at 20 South Potomac Street on the night of March 16, 1963. Bruno is pictured here in the rear of the building with its aerial piercing through the smoke. (Courtesy of the First Hagerstown Hose Company.)

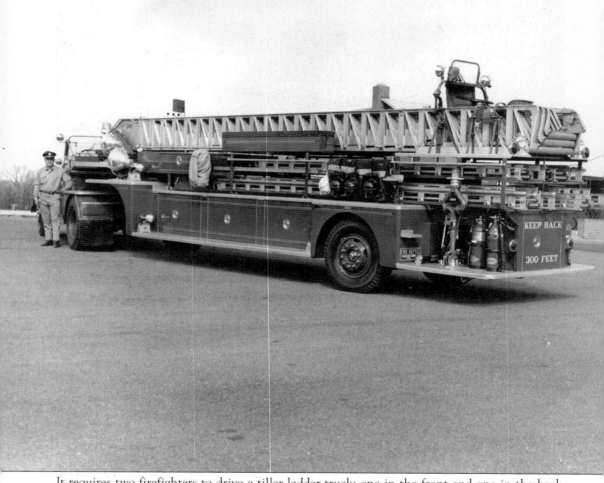

It requires two firefighters to drive a tiller ladder truck: one in the front and one in the back. The driver in the back is called the tillerman. The tillerman steers the rear wheels, allowing the truck to turn onto narrow streets and alleys. On this 1959 Pirsch ladder truck, the tillerman's seat is in the aerial ladder. When the aerial was needed the tillerman, would remove the steering wheel and pivot the windshield off to the side. A foot pedal released the seat. The seat would then flip up out of the way, leaving room for the aerial to be raised. An intercom system allowed communication between the driver and tillerman. Pioneer driver Charles McCoy is standing at the cab. (Courtesy of the First Hagerstown Hose Company.)

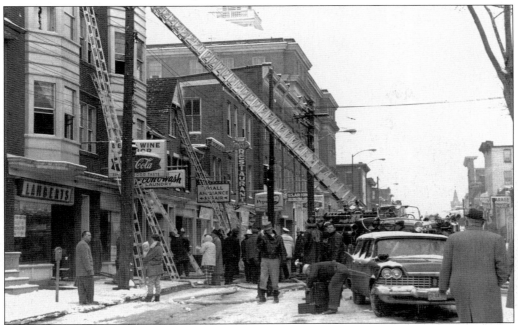

A row of businesses and apartments at 29 to 31 East Franklin Street were gutted by fire on the morning of February 12, 1962. The Small Appliance Repair Shop, Bennie's Barber Shop, Econo Self Service Laundry, Lambert Apartments, and Lambert Café were involved. (Courtesy of the First Hagerstown Hose Company.)

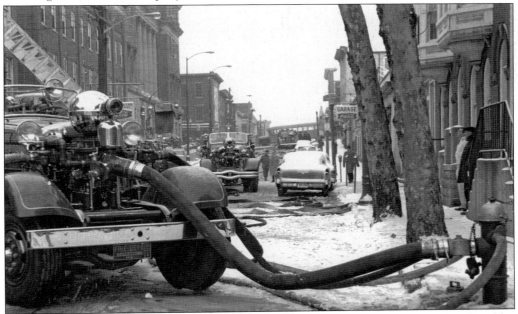

Three Hagerstown pumpers can be seen in this photograph at the building fires on East Franklin Street. The Hose Company's 1946 Ahrens-Fox is hooked up to the hydrant. The Antietam's 1948 Ahrens-Fox is next, followed by the Junior's 1947 Seagrave in the background. (Courtesy of the First Hagerstown Hose Company.)

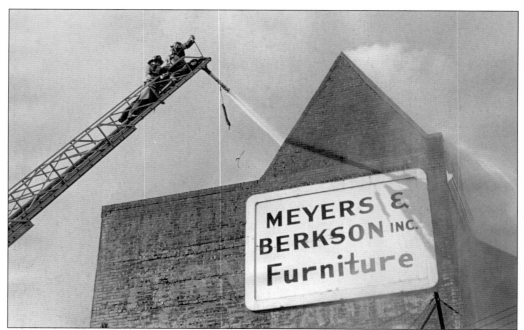

Firefighters on the tip of the Pioneer's ladder truck are applying 800 to 1,000 gallons per minute of water on the Myers/Berkson Furniture Company fire. The fire occurred on the afternoon of January 9, 1963. The building was in the unit block of West Franklin Street. (Courtesy of the First Hagerstown Hose Company.)

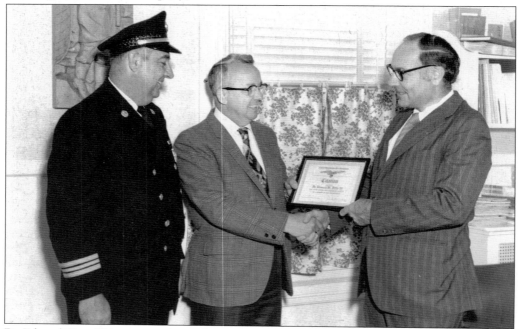

Dr. Edward Ditto III is receiving a certificate of recognition for his years of service as the Hagerstown Fire Department's physician. Pictured from left to right are Deputy Fire Chief C. William Karn, Fire Chief John Hall, and Dr. Ditto. (Courtesy of the Harry Daveler collection.)

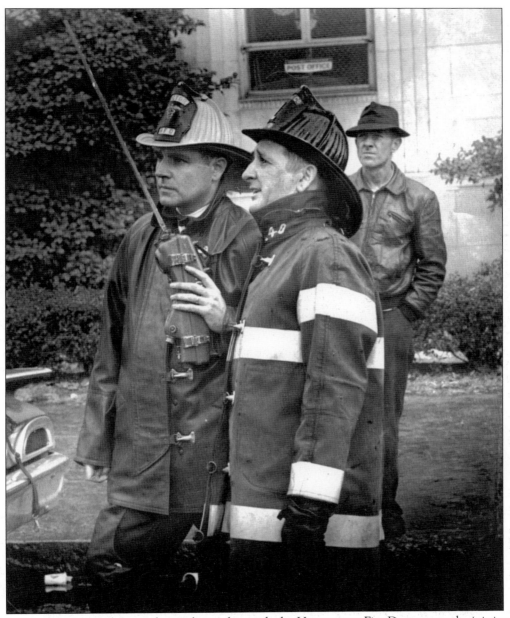

Dr. Edward Ditto III began a long relationship with the Hagerstown Fire Department by joining the First Hagerstown Hose Company on July 5, 1948. Prior to joining the fire department, he served with the Medical Corps of the U.S. Navy in the South Pacific from 1943 to 1944. He graduated from the Jefferson Medical College in 1952. Fire Chief Max Hoover asked Dr. Ditto to stand by at fires in case firefighters were injured. Chief John Hall provided Dr. Ditto with a set of turnout gear. Dr. Ditto is credited with saving the lives of several firefighters by detecting existing medical conditions during physical exams. Dr. Ditto served the fire department until his retirement on December 31, 1999. In this photograph, Dr. Ditto (left) is standing by with Firefighter Henry DeLauney (right) at the Byers/Berkson Furniture Company fire in 1963. (Courtesy of the Henry DeLauney collection.)

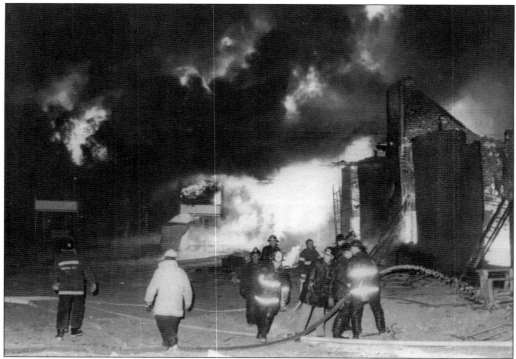

One apartment building was completely destroyed and one was partially damaged on December 2, 1965, at the North Spring Apartments on Haven Road. The buildings had been 85 percent completed at the time of the fire, which was fought by 75 to 100 firefighters. (Copyright *The Herald-Mail* Company, Hagerstown, Maryland.)

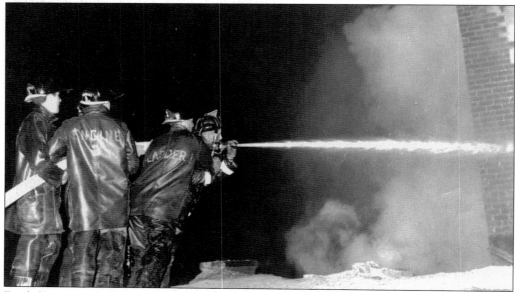

Firefighters are handling a two-and-one-half-inch solid stream hose line at the North Spring Apartment fire in 1965. Three firefighters were treated at the Washington County Hospital for injuries received while battling the flames. (Courtesy of the First Hagerstown Hose Company.)

Driver Ralph Foltz was on the scene of the Horner Manufacturing Company fire in 1966 with the Antietam's 1961 "B" Model Mack pumper. Driver Foltz served the Antietam Fire Company from 1948 to 1966. (Courtesy of the First Hagerstown Hose Company.)

Through the years, dogs have served as mascots and companions at firehouses. This is the Junior's mascot Blazer (tag no. 2701) lying in front of the firehouse on North Potomac Street. Blazer loved to ride on the pumper, sometimes leaning over and licking the driver's face while the pumper was going down the street. Driver George Basore is in the background. (Courtesy of the author.)

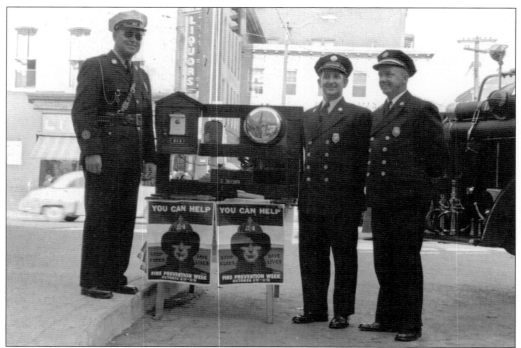

Fire Prevention Week is always the week of October 8 and 9, the dates of the Great Chicago fire and the Peshtigo, Wisconsin, fire in 1871. This fire prevention display was in the Public Square on October 6, 1958. Pictured from left to right are Hagerstown Police Officer Harry Young, Driver/Inspector Henry DeLauney, and Fire Chief John Hall. (Courtesy of the John Hersh collection.)

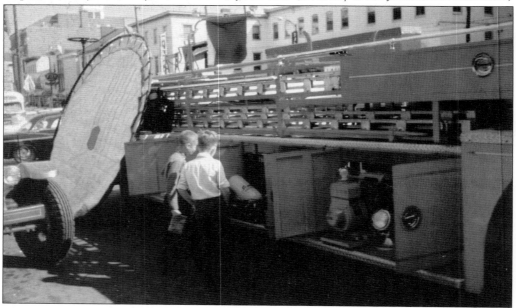

This fire prevention display in October 1960 included the Pioneer's 1959 Pirsch ladder truck. The boy on the right is Kyd Dieterich, who grew up to become a Hagerstown battalion chief. (Courtesy of the First Hagerstown Hose Company.)

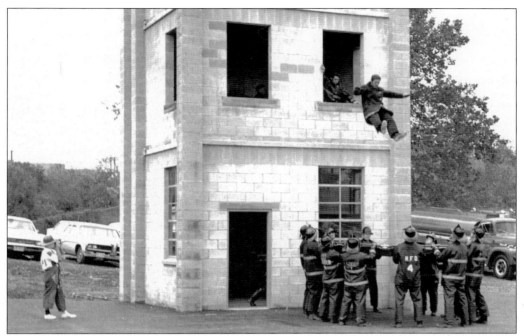

Firefighters are demonstrating their skills at the dedication ceremony of the Hagerstown Training Center on Bowman Avenue on October 5, 1969. A firefighter is jumping into a life net. Life nets were a good idea but not very practical. (Courtesy of the First Hagerstown Hose Company.)

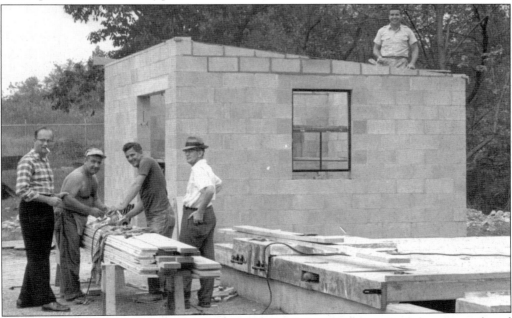

Construction of the Hagerstown Training Center began in 1959. Many firefighters contributed time and labor to the essential project. Pictured from left to right are Driver Charles Garrett, Driver Edgar "Skinny" Dellinger, Driver William Kershner, Luther Trumpower, and Driver Clyde Creek. (Courtesy of the William Kershner collection.)

Driver Clyde Creek was hired as a relief driver in 1956 at the age of 24. He eventually became the regular driver of the ladder truck at the Western Enterprise Fire Company. (Courtesy of the Harry Daveler collection.)

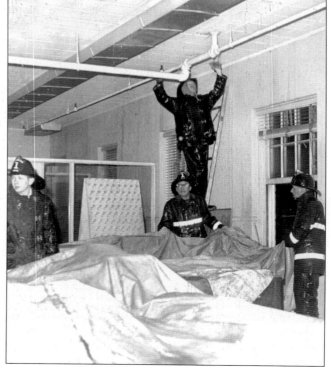

An important part of firefighting involves the protection of property. In this photograph, firefighters are stopping the flow of water from a sprinkler head. Salvage covers or tarps are used to cover furnishings. From left to right are firefighters Robert Carder, unidentified, Blaine Snyder, and unidentified.

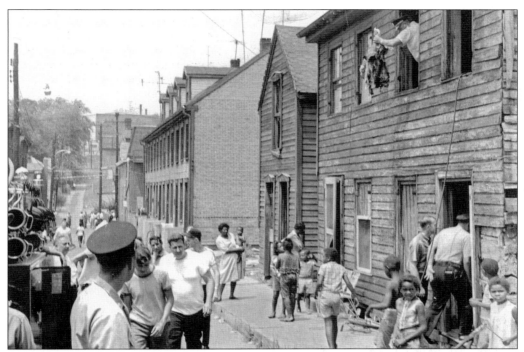

Firefighters are removing burnt contents from a fire on Bloom Avenue on July 10, 1968. Fires were frequent along this row of dilapidated buildings. A child playing with matches on the second floor was the cause of this fire. (Courtesy of the William Kershner collection.)

Kids love to come out in the summertime and watch the fire department in action. These kids are posing in front of the Antietam's 1961 Mack pumper. (Courtesy of the William Kershner collection.)

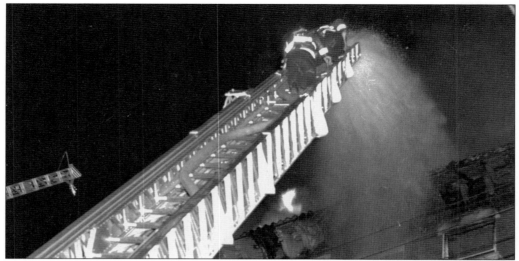

Fifteen families were left homeless when the top floor of the Mt. Vernon apartment building at 21 West Antietam Street burned on June 13, 1967. The Hagerstown Police Department assisted with evacuating several residents. The fire started at 4:10 a.m. and was completely extinguished by 8:15 a.m. (Courtesy of the First Hagerstown Hose Company.)

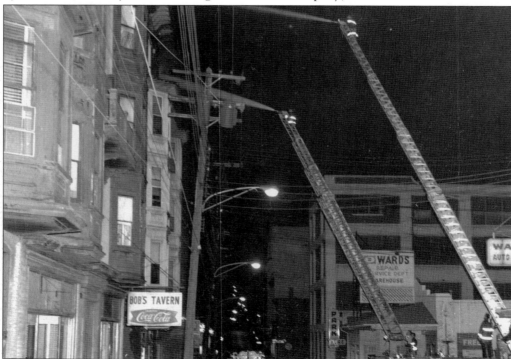

Several fire streams (ladder pipes) were required to bring this fire at 21 West Antietam Street under control. Approximately 60 firefighters fought the fire. Firefighters were able to save much of the merchandise on the first floor belonging to the Henson Dress Shop and Modern Shoe Store. After the fire, the height of the building was lowered by one floor. (Courtesy of the First Hagerstown Hose Company.)

Four

DOWNTOWN
CONFLAGRATIONS
1970–1989

Firefighter Charlie Evans of the Junior
Fire Company surveys the multitude of
hose lines stretched to extinguish a five-
alarm fire at the Maryland Apartments
building. This was the first of three major
fires to strike the downtown area in 1974.
(Courtesy of the Herb Smith collection.)

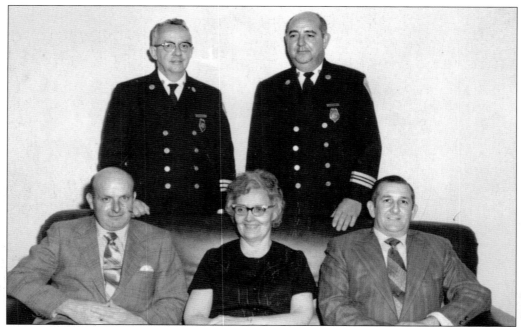

The management staff is a major component of the fire department. The staff manages the day-to-day operations and establishes long range goals. In the early 1970s, the staff consisted of, from left to right, (first row) Lt./Investigator Richard Smith, clerk-typist Ruth South, and Lt./Investigator Henry Delauney; (second row) Fire Chief John Hall and Deputy Fire Chief C. William Karn. (Courtesy of the Harry Daveler collection.)

Ruth South was the first clerk-typist assigned to the fire department on a permanent basis. She worked in the purchasing department from 1954 until she transferred to the fire department in 1969. In addition to official duties, she sewed on buttons and was a babysitter for the firefighters' children. The firefighters gave her the affectionate name of "Chester." (Courtesy of the Harry Daveler collection.)

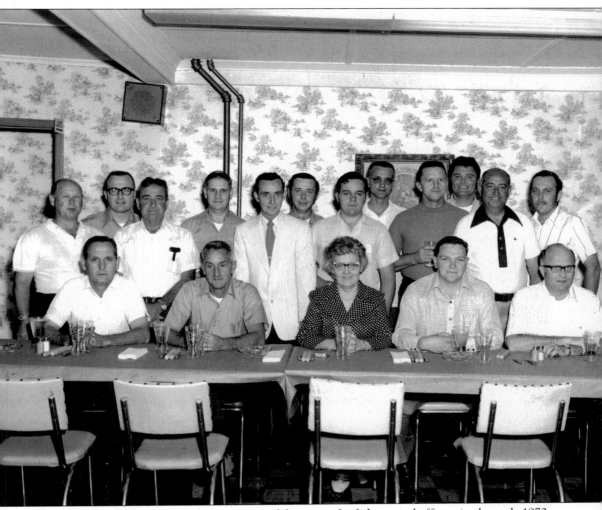

This photograph represents a large portion of the career firefighters and officers in the early 1970s at a large social function. Most firefighters become good friends on and off the job. Sometimes the shifts plan family events together. The fire department is a close-knit family. If a firefighter or family member is in need of assistance, the other firefighters are there to help. Pictured from left to right are (seated) Benjamin Conrad, Edward Elgin, Ruth South, Steve Johnson, and Charles Garrett; (standing) Elwood Higgs, William "Jug" Thompson, Edgar "Skinny" Dellinger, Harry Daveler, Herbert Sprecher, Mitchell Gearhart, Richard Kipe, Charles Baker, Charles Stone, Dave Deibert, C. William Karn, and Ronald Moser. (Courtesy of the Harry Daveler collection.)

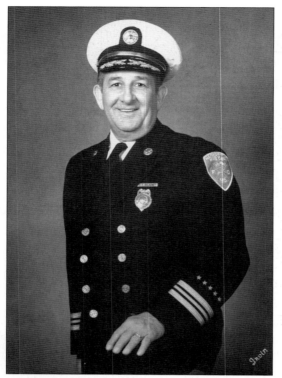

Henry DeLauney's firefighting career began at the Fairchild Aircraft Corporation in 1945. He joined the Antietam Fire Company in 1946 and was hired as a relief driver/inspector in 1953. His career path led him to the investigation side of the fire department. After serving two years as a lieutenant, he was promoted to deputy fire chief in 1973 overseeing inspections and communications. Deputy Chief DeLauney retired in 1981. (Courtesy of the Henry DeLauney collection.)

A proper license from the state of Maryland is required to drive fire apparatus. A tiller ladder truck requires a Class "A" (tractor trailer) license, and pumpers require a Class "B" (over 25,000 pounds weight) license. The state evaluator (center) is giving the test to Richard Kipe (left) and Robert Manley (right) on February 1, 1971. (Courtesy of the Harry Daveler collection.)

Driver Ronald Moser stands next to the Pioneer's 1948 American LaFrance ladder truck. He served as a relief driver/inspector, regular driver at the Pioneer Hook & Ladder Company, and fire investigator. Moser retired as a fire investigator with the state of Maryland. (Courtesy of the Harry Daveler collection.)

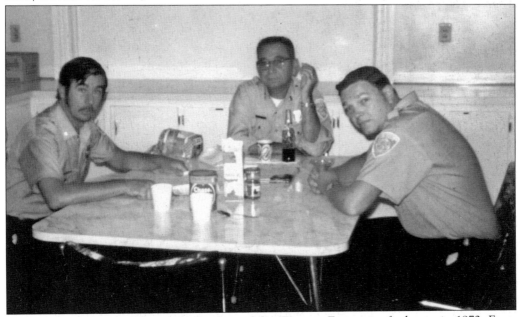

This photograph was taken in the kitchen of the Western Enterprise firehouse in 1972. From left to right are Drivers Glen Gorman, Lawrence "Bud" Gabe, and Steve Johnson. Whether he was responding to a gasoline spill or a block-long fire, Driver Gabe always kept his composure. (Courtesy of the William Thompson collection.)

Each volunteer company consists of administrative officers who are elected to manage each firehouse. These were the administrative officers at the Hose Company in 1973. From left to right are Sec. Jack Trovinger (joined in 1944 and served 47 years without missing a meeting), Second Vice Pres. Richard Henneberger, Pres. Charles Mobley (joined in 1913 and served as president for 32 years), First Vice Pres. Harry Feiser, and Treasurer W. Edward Heimel (joined in 1913 and served as treasurer for 50 years). (Courtesy of the First Hagerstown Hose Company.)

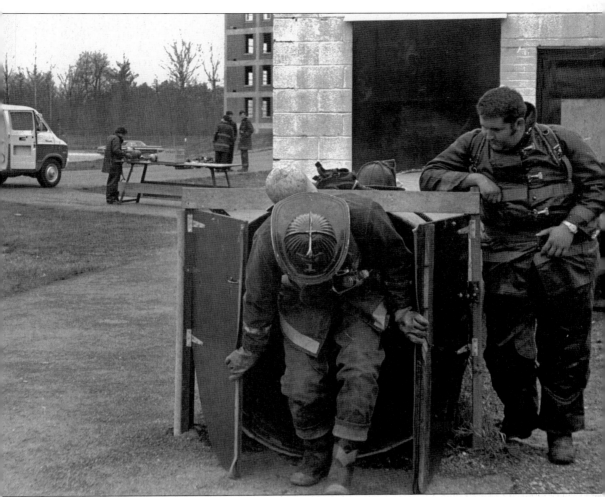

The Maryland State Fireman's Association initiated the first effort to provide formal fire training statewide in conjunction with the University of Maryland. The training program was referred to as the Fire College from 1930 to 1937, Fire Service Extension Department of the College of Engineering from 1935 to 1975, and the Maryland Fire and Rescue Institute from 1975 to the present. Antietam firefighter John Dellinger is standing on the right watching another firefighter come out of the training maze during the 1973 basic fire training class held at the training center in College Park. (Courtesy of the First Hagerstown Hose Company.)

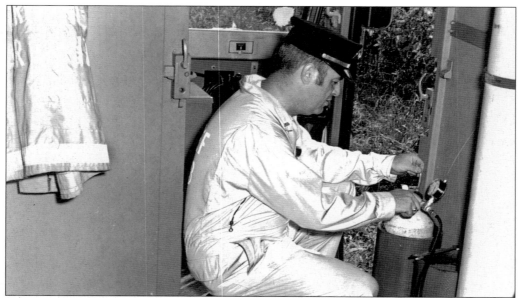

The Washington County Emergency Air Unit has filled air bottles for self-contained breathing apparatus at fire scenes since 1966. Chief Donald Koons has served as the chief of the air unit since its inception. Chief Koons joined the Hose Company in 1954 and served as assistant chief for five years. (Courtesy of the First Hagerstown Hose Company.)

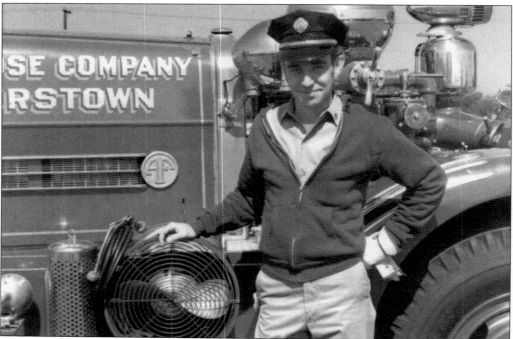

FAO Herb Sprecher entered the fire service as a volunteer with the Juniors in 1954. He was hired as a driver/inspector on January 4, 1967. FAO Sprecher served as a regular driver/dispatcher at the Hose Company and in 1980 as a driver at the Antietam Fire Company until his retirement on June 24, 1994. (Courtesy of the First Hagerstown Hose Company.)

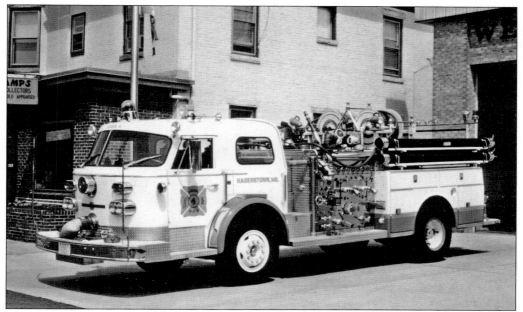

This is the Western Enterprise Fire Company's 1969 American LaFrance 900 series pumper. The pumping capacity was 1,000 gallons per minute, and it had a 300-gallon water tank. The photograph was taken in front of the Enterprise firehouse. (Courtesy of the Warren Jenkins collection.)

This is a bird's-eye view of Hagerstown's first line pumpers from 1972 to 1982. From left to right are the Hose Company's 1963 Pirsch, Antietam's 1961 Mack, Junior's 1965 Mack, Enterprise's 1969 American LaFrance, and South Hagerstown's 1972 Mack. Other units in the line include Community Rescue Service's Rescue Squad and Ambulance and the Washington County Emergency Air Unit. (Courtesy of the Richard Smith collection.)

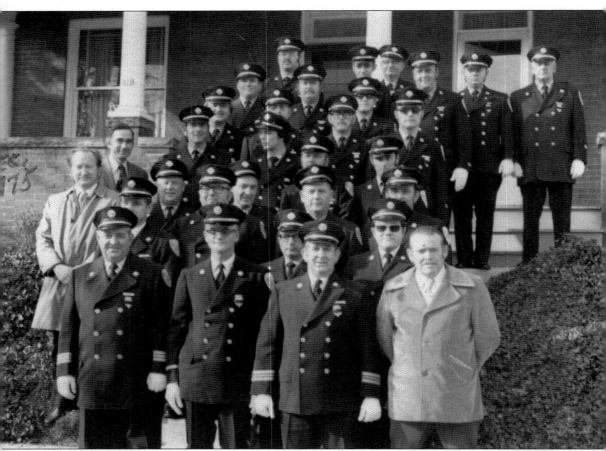

A majority of fire department personnel paid their respects to slain Hagerstown police officer Donald Kline on December 13, 1975. Officer Kline was shot while attempting to apprehend a robbery suspect. This photograph was taken in front of Deputy Chief DeLauney's residence on West Side Avenue. Pictured from left to right are as follows: (first row) Henry DeLauney and Maryland State Deputy Fire Marshal William Ramsey; (second row) C. William Karn, Charles Baker, Robert Papa, and Richard Kipe; (third row) C. Kingsley Poole, Fred White, Benjamin Conrad, and Ronald Moser; (fourth row) Maryland State Deputy Fire Marshal James Kittle, Elwood Higgs, Richard Trovinger, Leonard Barton, and Richard Jordan; (fifth row) Maryland State Deputy Fire Marshal Charles Cronouer, Richard Cramer, Robbie Dieterich, Dale Hill, and William Thompson; (sixth row) Ronald Horn, Charles Stone, and Wayne Smith; (seventh row) Richard Hopkins, Gary Hoffman, Herb Sprecher, and Charles McCoy; (eighth row) Tom Brown, Charles Flook, John Hersh, and William Kershner. (Courtesy of the Henry DeLauney collection.)

Here is FAO Charles Stone standing in front of the Enterprise's 1978 Seagrave ladder truck. Stone was hired in 1966, and after several assignments, he became the regular FAO at Western Enterprise. FAO Stone retired in 1985. The 1978 Seagrave ladder truck is now a reserve truck (Truck 37) in the Baltimore City Fire Department. (Courtesy of the William Kershner collection.)

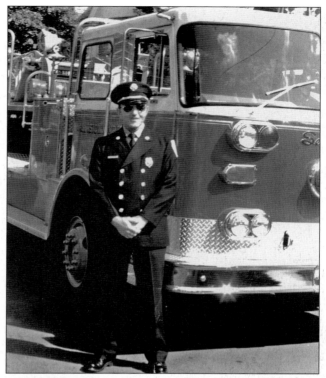

Everyone goes to the kitchen at the Pioneer for information relating to the day-to-day happenings in the fire department. From left to right are Drivers Larry Williams, Gary Hoffman, Steve Brezler, C. Kingsley Poole, Richard "Shakey" Cramer, and Charles Garrett (standing). (Courtesy of the William Thompson collection.)

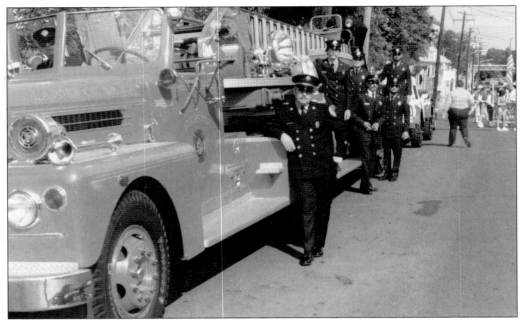

These firefighters with the Pioneer Hook & Ladder Company are participating in the 1983 fire prevention parade. From left to right are Pres. Charles Daley (in cab), Driver Leonard Barton, firefighters Todd Gelwicks, Glen Giffin, Jack Emory, Dean Baker, and Doug Spickler. (Courtesy of the William Dieterich collection.)

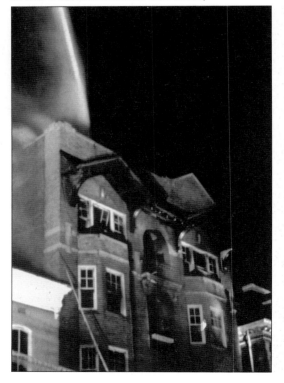

On the morning of February 8, 1974, fire ravaged the Maryland Apartments building in the unit block of South Potomac Street. About a dozen residents were evacuated via ladders. Exterior fire streams (ladder pipe operations) were necessary to extinguish the fire. (Courtesy of the Herb Smith collection.)

Smoke is still drifting from the Maryland Apartments fire the morning after the fire. About 100 firefighters battled the flames in 20-degree temperatures. The fire destroyed the entrance to the Maryland Theatre and four floors of apartments. (Courtesy of the Herb Smith collection.)

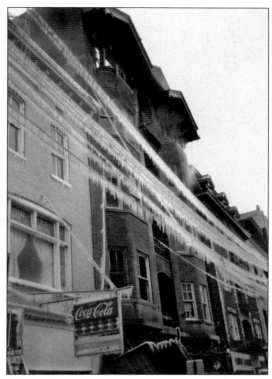

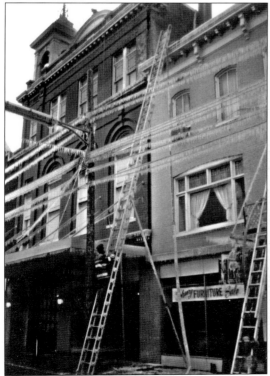

Without the quick actions of firefighters, the Maryland Apartments fire would have consumed many other buildings. Even the Hose Company, seen here on the left, was in danger of burning. The fire spared the Maryland Theatre auditorium. (Courtesy of the Herb Smith collection.)

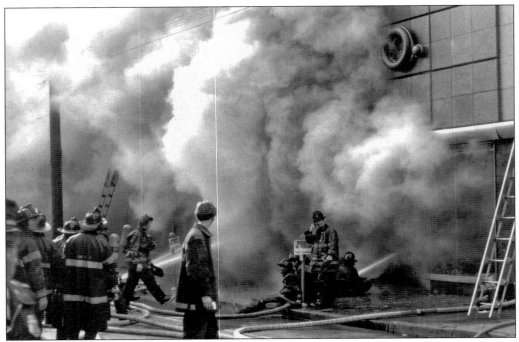

Firefighters are attempting to reach the seat of the fire at J. J. Newberry's Department Store with hand-held two-and-one-half-inch hose lines. The fire in the unit block of West Washington Street occurred on March 10, 1974. (Courtesy of the Herb Smith collection.)

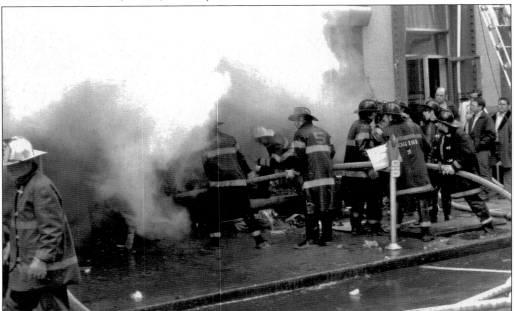

Over 125 firefighters battled the J. J. Newberry's fire for over 10 hours before declaring it under control. This was the second major fire to strike the downtown area in 1974. Twenty-five people, mostly firefighters, were treated on the scene for minor injuries. (Courtesy of the Herb Smith collection.)

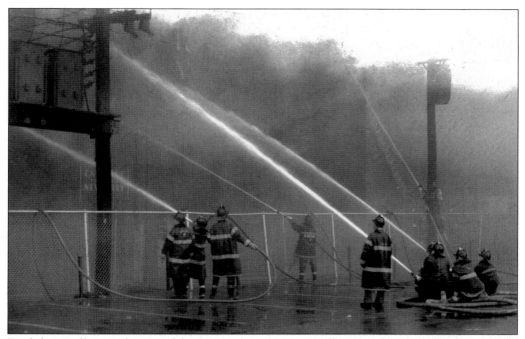

Firefighting efforts in the rear of the J. J. Newberry's store were hampered by the lack of windows to apply water to. These two-and-one-half-inch hose lines are trying to penetrate the intense flames and prevent the fire from spreading down the block. (Courtesy of the Herb Smith collection.)

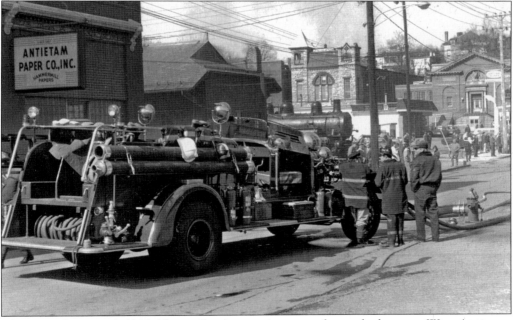

The Hose Company's 1946 Ahrens-Fox is pumping water from a hydrant on West Antietam Street during the J. J. Newberry's fire. Notice the steam engine and Litton's service center in the background. *The Herald-Mail* Company occupies the site today. (Courtesy of the William Dieterich collection.)

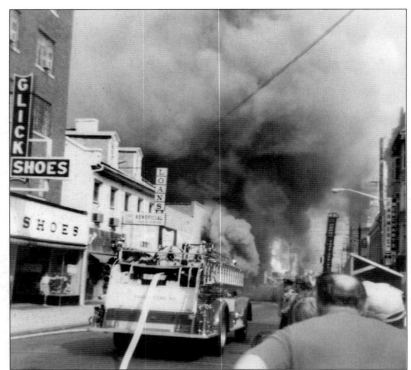

The fire apparatus arriving at the scene of the McCrory's Department Store fire on August 1, 1974, discovered heavy smoke showing from the front of the store. Firefighters know it's going to be a long day when they see this. (Courtesy of the Herb Smith collection.)

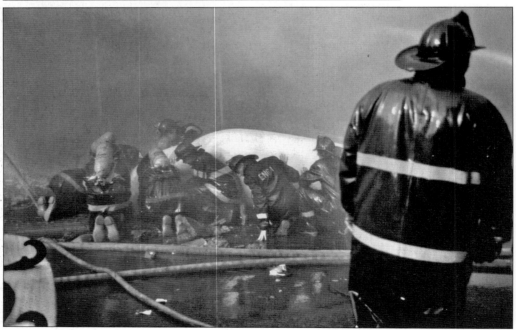

The McCrory's fire apparently originated in the basement. Some firefighters commented that this was the hottest fire they had ever fought. The heat in the basement was intense. High expansion foam was brought in from Frederick in an attempt to suppress the fire in the basement. (Courtesy of the Herb Smith collection.)

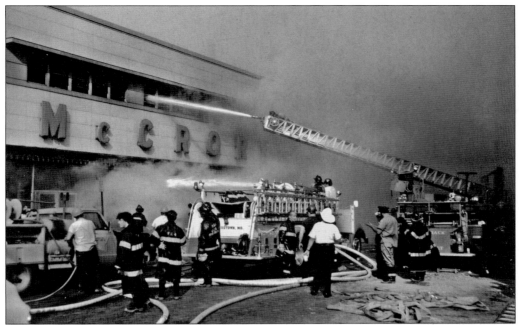

Firefighters with the Pioneer's 1959 Pirsch ladder truck have reverted to exterior fire streams (ladder pipe operations) at the McCrory's fire. Firefighters remained on the scene for over 24 hours. The fire was contained to the McCrory's store only. (Courtesy of the Herb Smith collection.)

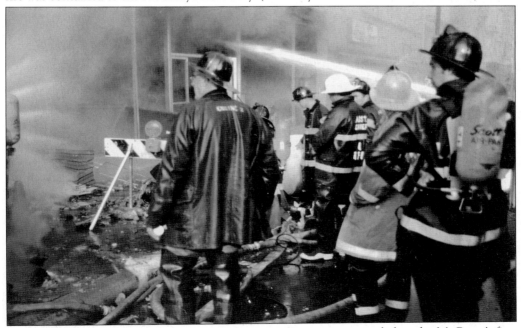

Over 100 firefighters from Hagerstown and surrounding areas responded to the McCrory's fire. The firefighter in the foreground wearing the Engine 2 turnout coat is Harry "Doc" Shilling. To Shilling's right is Western Enterprise's assistant chief Donnie Palmer. (Courtesy of the Herb Smith collection.)

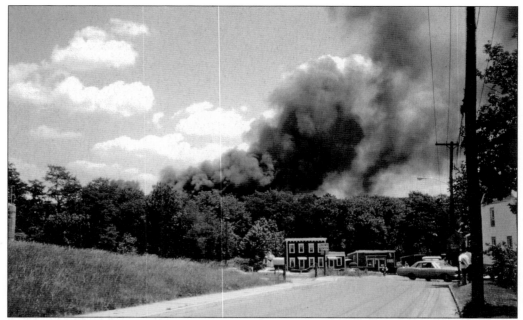

This heavy cloud of black smoke is coming from an asphalt plant fire on Mitchell Avenue on June 5, 1976. The blaze started as a result of a boiler malfunction. This photograph was presented to the author by Firefighter Jackson Gearhart shortly before he died in the line of duty at a fire in Franklin County, Pennsylvania.

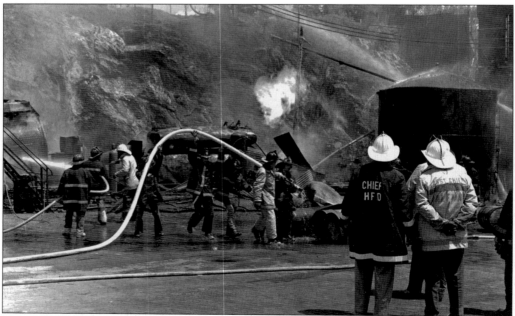

This is a close-up view of firefighters in action at the Bester-Long Asphalt Plant fire on Mitchell Avenue. The fire involved a combination of naphtha, oil, and kerosene. The nearest hydrant was 2,000 feet away. Nearly five years later to the day, fire struck the asphalt plant again. (Courtesy of the First Hagerstown Hose Company.)

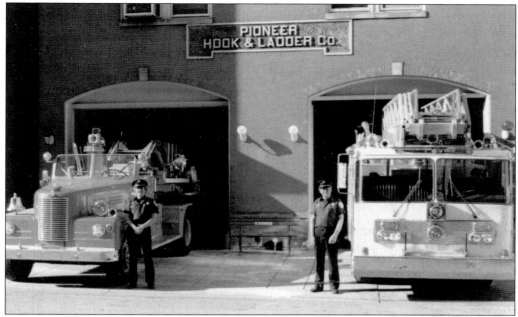

Sometimes the regular FAOs on the ladder trucks work together for many years. They work, eat, and sleep in the same firehouse. Often they establish a bond that lasts a lifetime. Pioneer Hook & Ladder FAOs Andy Hartman (left) and Larry Williams (right) developed such a friendship. (Courtesy of the Tom Brown collection.)

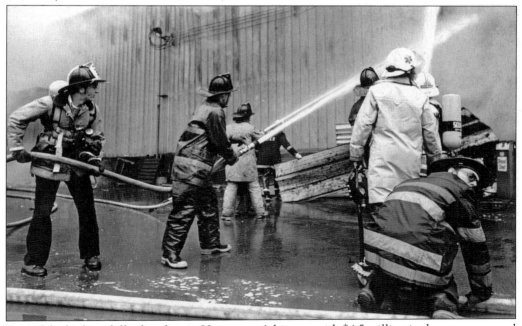

One of the highest dollar-loss fires in Hagerstown's history, with $4.5 million in damage, occurred on November 21, 1977, at the Creasey Company warehouse in the 300 block of West Franklin Street. The building was a wholesale grocery warehouse. Over 125 firefighters fought the fire for 10 hours before bringing it under control. (Courtesy of the First Hagerstown Hose Company.)

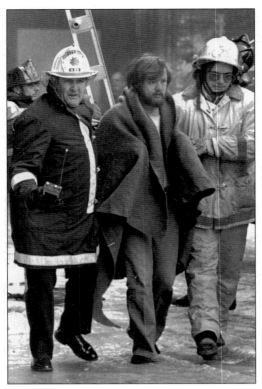

When firefighters arrived at an apartment building fire on February 1, 1977, some residents were hanging out of the windows waiting to be rescued, which all of them were. In this photograph, Deputy Chief Henry DeLauney (left) and a member of the Community Rescue Service are assisting a resident who was rescued from the fire. (Courtesy of the Henry DeLauney collection.)

In addition to apartments on the upper floors, the Glick Shoe store was on the first floor. Seventy firefighters fought the 1977 blaze in sub-freezing temperatures. The dome of the building on the right was destroyed by a fire in 1987. (Courtesy of the First Hagerstown Hose Company.)

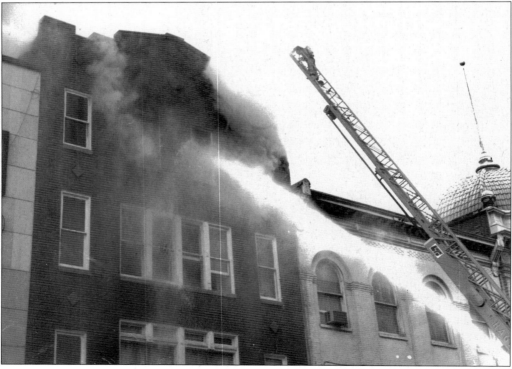

Fire Chief Richard Smith's career began as a volunteer in 1953 with the Pioneer Hook & Ladder Company. He was hired as a relief driver/inspector in 1959. By 1971, he was appointed lieutenant and in 1974 became the deputy fire chief. In 1976, he became the third paid fire chief in Hagerstown's history. (Courtesy of the Richard Smith collection.)

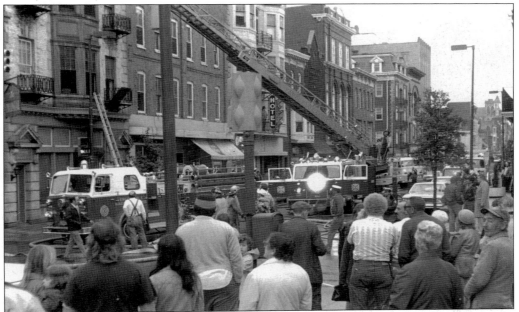

Residents of the Colonial Hotel/Apartments were forced to flee to the windows as a fire in the hallway blocked their exits. Ten residents were treated for injuries, but all survived thanks to the firefighters' efforts. This fire was on the same day that Pres. Ronald Reagan was shot in Washington, D.C.—March 30, 1981. (Courtesy of the First Hagerstown Hose Company.)

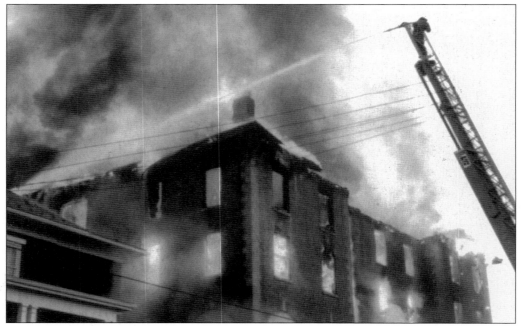

When a fire department needs assistance from neighboring jurisdictions, the term used is mutual aid. On the morning of November 17, 1980, nearly all fire companies in Washington County were dispatched to the Hancock Center Apartments fire in Hancock. The Pioneer's 1973 Oren/Hendrickson ladder truck's fire stream (ladder pipe operation) is preventing the fire from spreading down the block. (Courtesy of the Kyd Dieterich collection.)

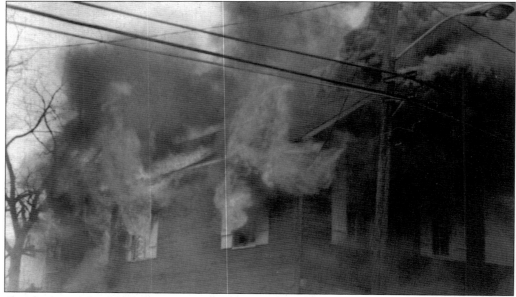

Another mutual aid call for assistance was received on the morning of November 26, 1982, in the village of State Line, Pennsylvania. Fire ripped through the recently closed Candle Shoppe store. The Pioneers ventilated the roof to remove heat and smoke; however, the building was a total loss. (Courtesy of the Kyd Dieterich collection.)

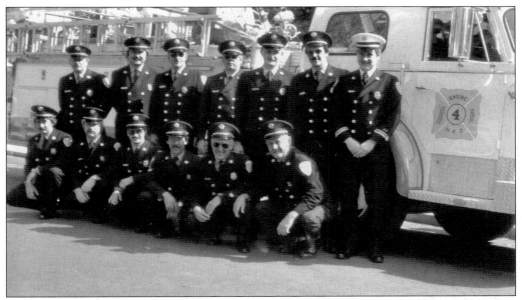

This is "B" shift participating in a 1983 fire prevention parade. From left to right are (first row) FAOs Kyd Dieterich, David Baer, Carroll Wollard, Randy Myers, Richard Trovinger, and Benjamin Conrad; (second row) Leonard Barton, Ronald Horn, Charles Stone, Michael Ward, Frank Ridenour, Larry Koons, and Battalion Chief C. Kingsley Poole. (Courtesy of the First Hagerstown Hose Company.)

In 1982, a cadet program was initiated. The concept involved hiring and training firefighters to be prepared to step into an FAO's position when an opening occurred. Cadets worked 40 hours per week and the pay was $3.75 per hour. One of the cadets was Tom Papoutsis, shown here rappelling from the training tower on Bowman Avenue. (Courtesy of the Richard Smith collection.)

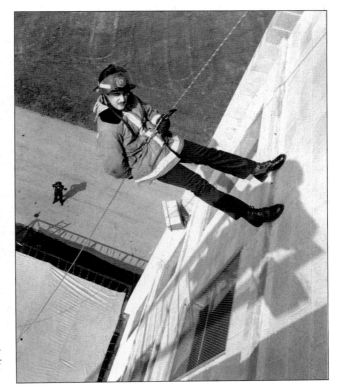

Members of the Hose Company pause for a photograph near the entrance of the Hose Company's original 1815 home at Saint John's Lutheran Church at 141 South Potomac Street. From left to right are Robert Hammond, John Miller, Jack Trovinger, Robert Lewis, Eric Rider, Carl Stahl, Robert Kibler, Blaine Snyder, and Bryan Stallings. (Courtesy of the First Hagerstown Hose Company.)

Chief Smith is discussing plans with members of the Western Enterprise Fire Company and Councilman Ron Coss. From left to right are Ron Coss, Roy Cromer, unidentified, Clyde Tressler, Richard Smith, Dennis Cosgrove, and Charles Barr. (Courtesy of the First Hagerstown Hose Company.)

Five

DAWN OF A NEW MILLENNIUM 1990–2005

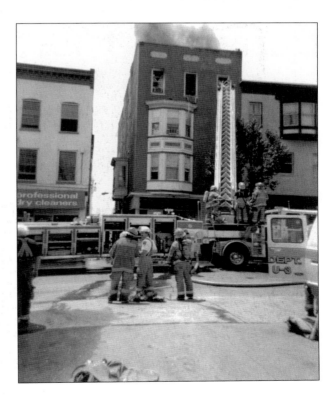

Firefighters arrived at 59–61 West Franklin Street on July 27, 1999, to find fire showing from the fourth floor. Six apartments occupied the second through fourth floors of the building. The first floor was at one time occupied by Leon's Hoagie Shop, a favorite firefighter hang out. (Courtesy of the author.)

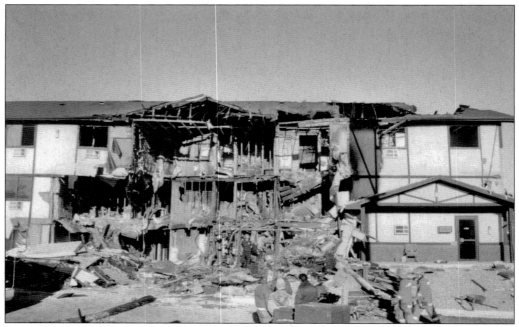

Four persons perished and ten were injured after an explosion ripped through the Super 8 Motel on the Dual Highway on February 18, 1990. This is believed to be the largest loss of life at any one fire in Hagerstown's history. Firefighters rescued at least seven people from windows. Some people tied bedsheets together to make their escape. (Courtesy of the author.)

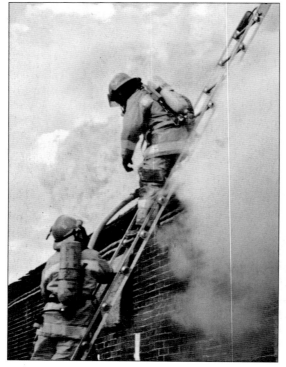

On the evening of April 10, 1991, a wind-driven fire at the Leed's Men's Store in the unit block of West Franklin Street put firefighters to the test. Over 100 firefighters fought to contain the fire for over four hours before declaring it under control. (Courtesy of the Edward Hood III collection.)

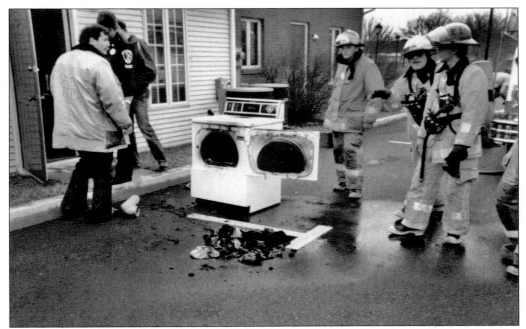

Major fires are only a small percentage of the total incidents for any year. Most incidents are relatively minor but without intervention could become serious. This dryer fire at 330 Mill Street on December 22, 1990, is one example. From left to right are Battalion Chief Richard Hopkins, FAO Larry Williams, unidentified, and Firefighters William King, Rodney Hottle, and Eric Rider. (Courtesy of the author.)

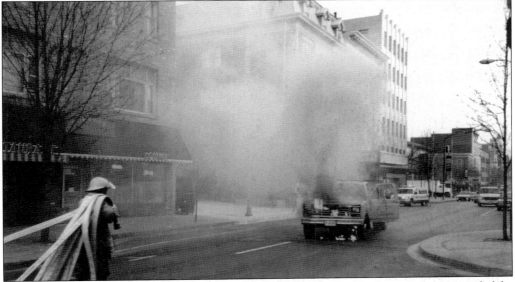

On a cold winter morning in February of 1995 during a shift change, a street alarm sounded for the Public Square. As the bay door of the Hose Company went up, it became obvious that the fire was right in front of the firehouse. The driver of this truck had just left a repair shop when he heard a loud bang and realized his truck was on fire. The firefighter stretching the hose line is Kenny Norris. (Courtesy of the author.)

FAO Randy Hinkle became a volunteer firefighter with the Antietam Fire Company in 1973. He was hired by the fire department on July 4, 1979. After working several relief and regular positions, he became the regular driver at South Hagerstown in 1984. FAO Hinkle succumbed to a long illness in December of 1997. (Courtesy of the Heather Hinkle collection.)

Veteran FAO Richard Jordan takes a break after a house fire at 423 North Mulberry Street on January 9, 1991. The fire was dispatched as an electrical fire. Upon the firefighters' arrival, it had already spread from the basement through the walls and into the attic. The firefighters worked very hard to contain the fire. (Courtesy of the author.)

Fire Chief Gary Hawbaker (center) is flanked by veteran assistant fire marshals John Hersh (left) and Wayne Smith (right). Assistant Fire Marshal Hersh made 301 juvenile arrests and 91 adult arrests from 1982 to 2001. Assistant Fire Marshal Smith is known for his excellent work as a fire inspector. Chief Hawbaker has served as fire chief from 1985 to the present. (Courtesy of the Gary Hawbaker collection.)

The fire marshal's office plays a vital role in protecting the citizens of Hagerstown. The office conducts building inspections, fire investigations, and fire/life safety instruction. From left to right are Fire/Life Safety Educator Michael Weller, Assistant Fire Marshals John Hersh and Wayne Smith, and Fire Marshal Tom Brown. (Courtesy of the Tom Brown collection.)

C. Kingsley Poole (left) served as battalion chief II for over 26 years. He entered the fire service as a volunteer with the Funkstown Fire Company in 1962 and the Antietam Fire Company in 1963. Poole was hired as a relief driver in 1969. After serving three months at Western Enterprise (Truck 4), he served one year as the regular driver at the Hose Company. He went on to work as an inspector II and investigator II before being promoted to battalion chief on July 9, 1975. He served as a battalion chief until his retirement on December 1, 2001. Chief Poole's position was filled by Battalion Chief Randy Myers (right). Myers entered the fire service as a volunteer with Rescue Hose Company No. 1 of Greencastle, Pennsylvania. After being hired in Hagerstown as a relief driver in 1978, he served as a regular driver at South Hagerstown, Independent Junior, and Western Enterprise before being promoted to captain and subsequently battalion chief. (Courtesy of the Randy Myers collection.)

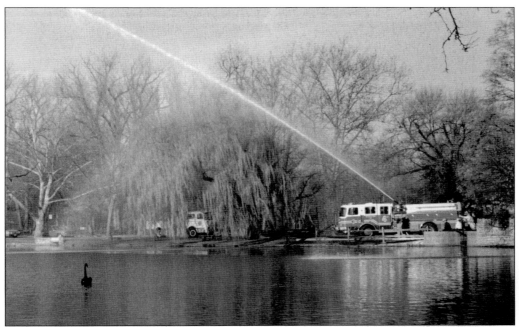

The Hagerstown City Park is one of the most picturesque parks in the country. The fire department has utilized the park for training purposes for years. Water is drafted from the lake with a pumper and returned via a deluge nozzle. Notice the black swan in the foreground. Families enjoy coming out to view the waterfowl. (Courtesy of the author.)

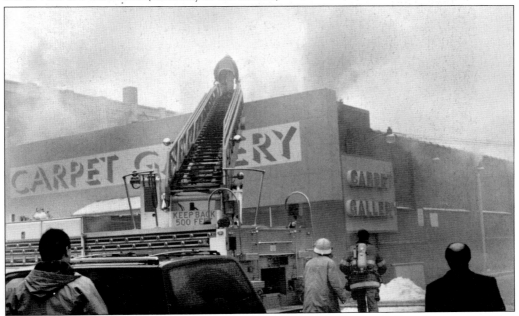

The flue in a wood-burning furnace was blamed for a fire at the Carpet Gallery Store at 120 West Franklin Street on January 7, 1993. The fire caused over $300,000 in damages. This was newly appointed captain Brian Pile's first fire as an incident commander in Hagerstown. (Courtesy of the William Kershner collection.)

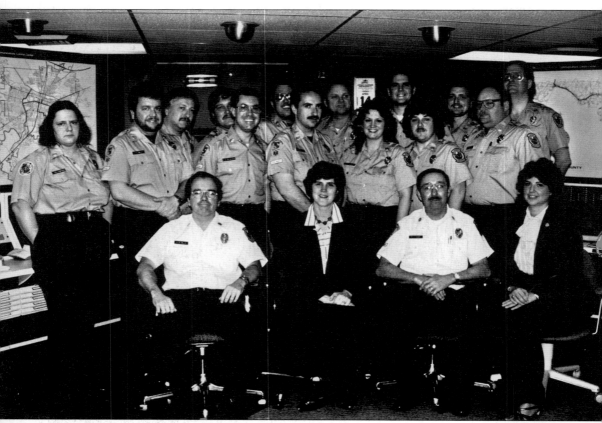

Most emergency incidents begin with a phone call to the Washington County Fire and Rescue Communications Center (911). Good communications are an important part of an emergency incident. Pictured from left to right are (first row, seated) Deputy Chief Sid Mills, Citizens Services Coordinator Kathleen Riley, Chief Ron Karn, and Sec. Verna Brown; (second row) Technicians Lisha (Sollenberger) Bikle, Tom Bikle, Robert S. Kefauver, Roy Lescalleet, Bardona (Holsinger) Woods, James Blevins, and William DeLauter; (third row) David Pheil, Keith Bowen, Jeffrey Ringer, Herbert Smith, Richard Conrad, Phil Ridenour, and Michael Shifler. (Courtesy of the Washington County Communications Center.)

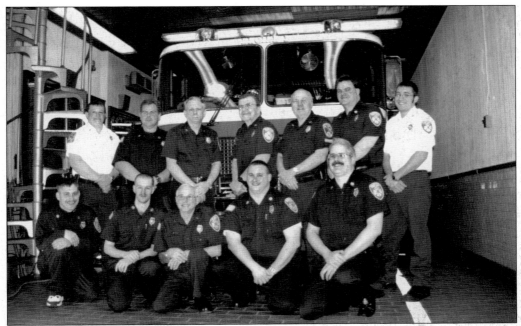

These are the First Hagerstown Hose Company's 2005 operations officers and firefighters. From left to right are (first row) Firefighters Andy Smith, Chuck Reger, Richard Stallings, Bryan Stallings, and Rob Hade; (second row) Capt. Tony Lida, Lt. Frank Shupp, Firefighters Gerry Saum, Greg Baker, Blaine Snyder, and William King, and Lt. Scott Reese. (Courtesy of the William King collection.)

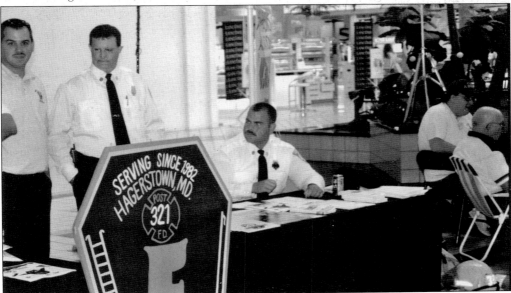

Explorer Post 321 was established to give area youth the opportunity to experience firefighting activities before they are old enough to join a fire company. This program is an excellent first step towards becoming a firefighter. From left to right are advisor Andrew West, Capt. Tony Lida, and Lt. Frank Shupp. (Courtesy of the First Hagerstown Hose Company.)

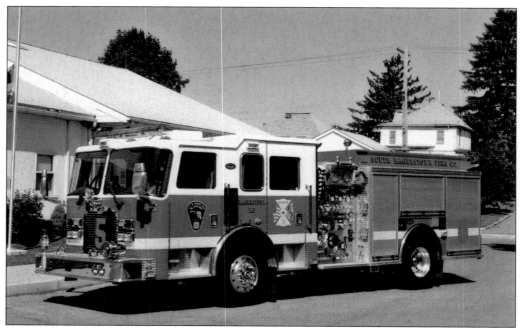

This 2004 Kovatch Mobile Equipment Company (KME) pumper (Engine 5) was placed in service in February 2004. Its pumping capacity is 1,500 gallons per minute, and the water tank holds 500 gallons. (Courtesy of the Warren Jenkins collection.)

These Hagerstown Fire Department officers and firefighters attended the dedication ceremony for South Hagerstown's new pumper. Pictured from left to right are (first row) Deron Malcolm, Tim Shafer, Joey Reichert, Frank Ridenour, Brian Pile, and Justin Mayhue; (second row) Harry Daveler, Gary Hoffman, Randy Myers, Kyd Dieterich, Ronald Horn, Richard Trovinger, and Alan Gladhill. (Courtesy of the author.)

These South Hagerstown firefighters were pleased to put the 2004 KME pumper in service. From left to right are William Dieterich, Jason Calvert, Rodney Hottle, Capt. Wayne Hottle, Justin Mallott, Richard Hottle, Richard Trovinger, Jay Rowland, Greg Patterson, and Cecil Bittinger. (Courtesy of the author.)

It is a tradition in the fire department for the firefighters to push a new piece of apparatus into the firehouse. Members of South Hagerstown are continuing that tradition in this photograph. (Courtesy of the author.)

The Antietam Fire Company was organized as early as 1808 under the name LaFayette Fire Company. In 1835, the company was incorporated as the Antietam Fire Company. Pictured from left to right are the following: (first row) Herb Bowman, Chuck Cunningham, Walter Logsdon, Isaac Doleman, Harry Daveler, Charles Cunningham, Ron Malloy, William Dunham, and Bobby Daveler; (second row) Robert McGhee, Brian Sheppard, James Sprecher Jr., Jeffrey Snyder, Craig Sheppard, Harold Semler, Mark Schlotterbeck, Terry Barnes, Travis Barkdoll, Rick Dellinger, Gary Harbaugh, and Marty Wright; (third row) Jeffrey Snyder, Courtney Drury, Donnie Boward, James Sprecher III, Brandon Higgins, Toby Higgins, Ed Bryan, Sam Morris, D. K. Morgan, and Brian Elgin. (Courtesy of the Larry Allen and Company.)

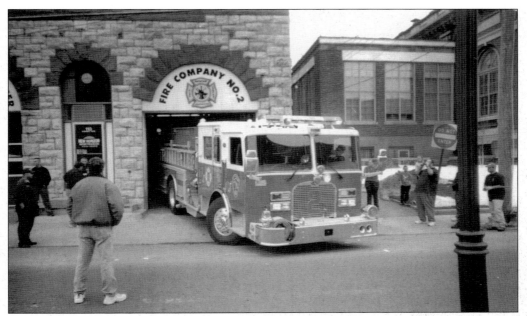

The Antietam Fire Company placed this 2004 KME pumper in service on February 14, 2004. Its $270,000 cost was equally divided between the City of Hagerstown and the Antietam Fire Company. It is equipped with a 1,500-gallon-per-minute pump, 500-gallon water tank, and roll up doors that allow easier access to compartments. (Courtesy of the author.)

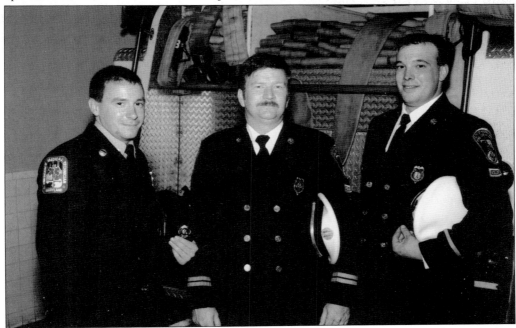

Sometimes life around the firehouse becomes a family affair. In this photograph are three members of the same family who are all members of the Antietam Fire Company. From left to right are FAO James Sprecher III (son), Capt. James Sprecher Jr. (father), and Lt. Travis Barkdoll (son-in-law). (Courtesy of the Larry Allen and Company.)

Retired FAO Mitch Gearhart was a very dedicated firefighter. He faithfully served as president, treasurer, and member of the honor guard of the firefighters' union (International Association of Firefighters, Local 1605). Gearhart was hired on February 16, 1966, as a relief driver/inspector. The majority of his career was spent at the Antietam Fire Company. (Courtesy of the Larry Allen and Company.)

It is important that retired firefighters continue an affiliation with the fire department long after they retire. Their knowledge and experience is valuable to younger firefighters. From left to right are retired FAOs Harry Daveler, William Dieterich, and Richard Trovinger. (Courtesy of the author.)

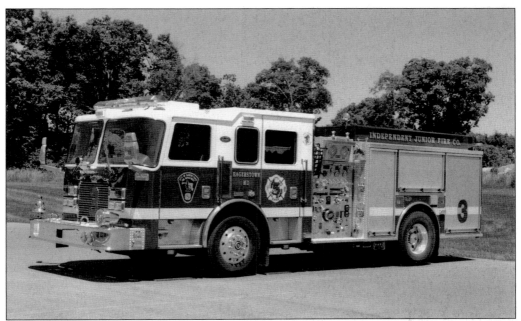

On February 14, 2004, the Independent Junior Fire Company placed in service this 2004 KME pumper. It is painted in the Junior's traditional green. The Junior purchased a thermal imaging camera, which allows firefighters to find victims in smoke, and remote video equipment, which allows images on the camera to be viewed outside a structure. (Courtesy of the Warren Jenkins collection.)

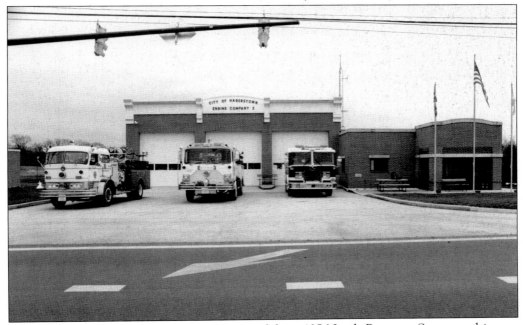

The Independent Junior Fire Company moved from 105 North Potomac Street to this new firehouse on Eastern Boulevard in November 1993. The pumpers represent three generations: from left to right are the Junior's 1965 Mack, 1982 Mack, and 2004 KME. (Courtesy of the James Balogh collection.)

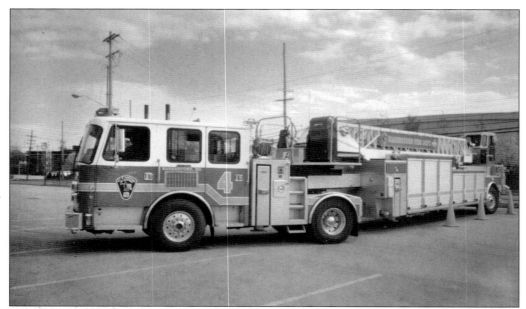

Many hours of training are required for firefighters to learn new skills and refine existing skills. Annual refresher training in EMS, Hazmat, and driving the apparatus are a few examples. FAOs are practicing driving skills with the aid of cones in this photograph. (Courtesy of the author.)

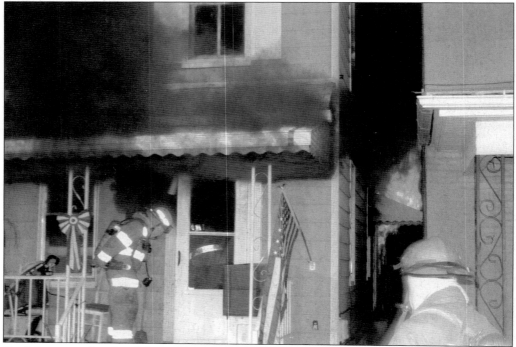

Firefighters are faced with heavy smoke and fire at this house at 711 South Potomac Street on September 23, 2004. The fire was quickly contained, but the home experienced heavy smoke and heat damage. Firefighters normally attack a fire from the unburned area in an effort to confine the fire to the area already burned. (Courtesy of the Washington County Photo Team.)

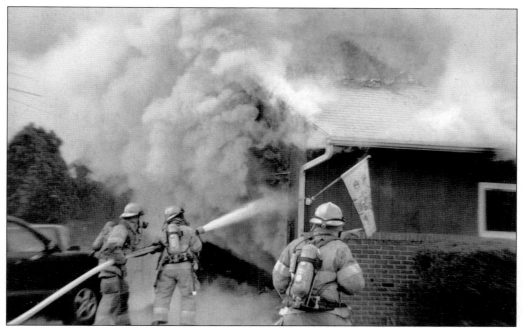

This May 15, 2004, fire was reported as a garage fire. The garage on Kenwood Drive was on fire; however, it was also attached to the house. Firefighters were able to contain the fire mostly to the garage. (Courtesy of the Steve Eichelberger collection.)

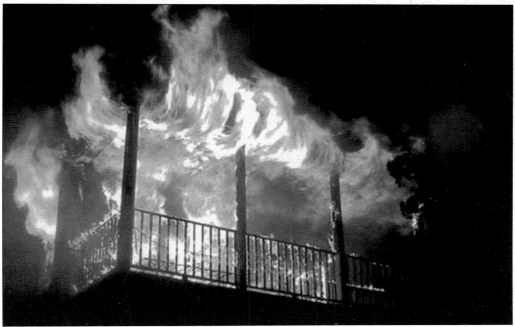

The housing in Hagerstown includes many apartment buildings. Any time a fire strikes, the potential exists for a large loss of life. Firefighters methodically search entire buildings for trapped occupants. All occupants escaped serious injury at this spectacular fire at 23 South Cannon Avenue on September 14, 2004. (Courtesy of the Terry Zeigler collection.)

The career firefighting force is divided into three shifts. This is "A" shift in 2004. A shift's motto is "Just get 'er done." Pictured from left to right are (kneeling) FAOs Scott Baire, Chris Gelwicks, Adam Hopkins, Dan Garnand, Jeb Eckstine, and James Sprecher III; (standing) Battalion Chief W. Kyd Dieterich, FAOs Steve Mitchell, Robert Herr, Richard Conrad, James Stevens, James Kershner, Jerry Cunningham, Robert Maurer, James Balogh, Ronald Randall, Leonard Shockey, and Edward Shindle, and Capt. Justin Mayhue. (Courtesy of Photography by Dale.)

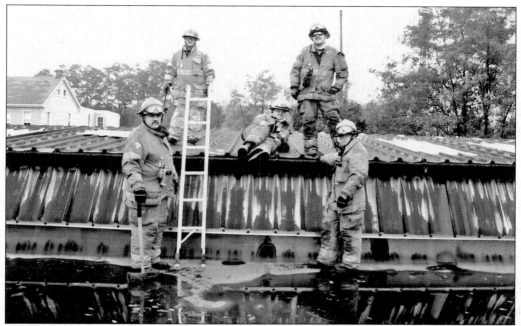

In October 2004, a vacant building on Main Avenue was offered to firefighters for training purposes. These firefighters are taking a break during ventilation training. Pictured from left to right are (first row) FAOs Steve Mitchell and James Sprecher III; (second row) James Stevens, James Kershner, and Jeb Eckstine. (Courtesy of the James Balogh collection.)

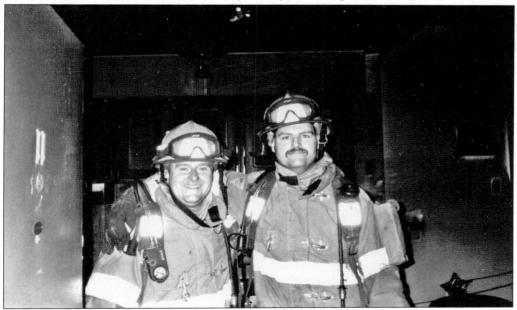

FAOs James Balogh (left) and Scott Baire (right) were both hired in early 2002. They have developed a good working relationship while working together on Utility 3, a GMC van with a minimum crew of two firefighters that responds to every incident in Hagerstown to supplement any lack of personnel on other apparatus. (Courtesy of the James Balogh collection.)

FAO Richard Conrad (left) is a second-generation Hagerstown firefighter. His father, Benjamin Conrad, was the FAO at the Junior for nearly 33 years. Richard (Rick) was hired in 1990. This was FAO James Balogh's (right) first shift as a relief driver on January 8, 2004. (Courtesy of the James Balogh collection.)

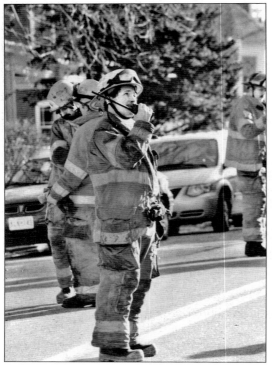

This is author Justin Mayhue in command of an apartment fire at 429 Summit Avenue on February 19, 2005. Each shift is commanded by a battalion chief and assisted by a captain. When the battalion chief is off duty, the captain is responsible for managing the shift. (Courtesy of the James Balogh collection.)

Firefighters worked hard to gain access to and extinguish the apartment fire at 429 Summit Avenue. The electrical fire was burning in the attic space. The ceilings on the third floor were pulled down to gain access to the fire. Pictured are FAOs Steve Mitchell (left) and Jeb Eckstine (right). (Courtesy of the James Balogh collection.)

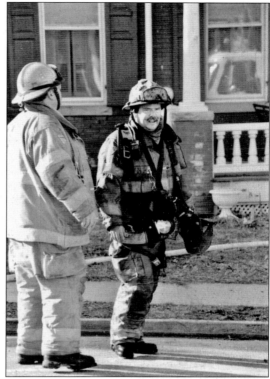

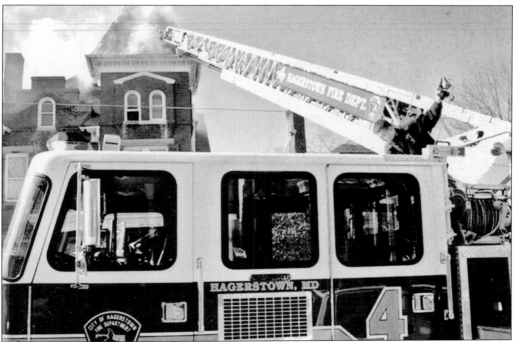

FAO Chris Gelwicks navigated the aerial through power, cable, and telephone lines to reach the roof of the attic fire at 429 Summit Avenue. (Courtesy of the Steve Eichelberger collection.)

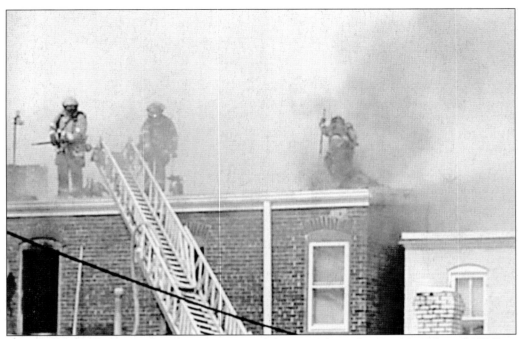

A child playing with matches was the cause of this two-alarm fire at 123, 125, and 127 East Washington Street on February 25, 2005. Firefighters are ventilating the roof to remove smoke, heat, and gases from the building. (Courtesy of the Washington County Photo Team.)

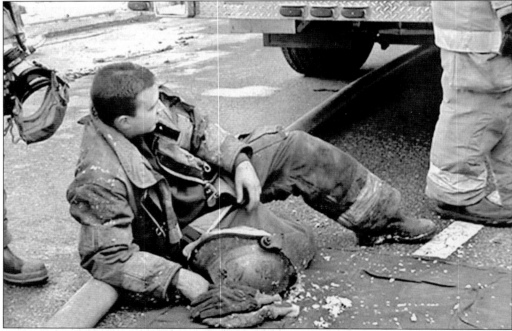

FAO Chris Gelwicks takes a break after fighting the fire on East Washington Street. The ceilings and insulation were pulled down from the third floor to gain access to the rapidly spreading flames. (Courtesy of the Washington County Photo Team.)

Driver Aaron Kretzer McGraw was responsible for taking and collecting many of the photos used in this book. A. K. passed away in 1985, but his legacy and contribution to the fire department lives on through his love of photography and history. (Courtesy of the First Hagerstown Hose Company, A. K. McGraw collection.)

Author Justin Mayhue joined the fire service family as a volunteer firefighter at the Longmeadow Volunteer Fire Company in November 1977. He was hired as a cadet/firefighter in 1983. After serving four years as a relief driver, he became the regular driver at the Hose Company from 1988 until being promoted to captain in 2002. (Courtesy of Photography by Dale.)

ACKNOWLEDGMENTS

It is with humble gratitude that I acknowledge the following individuals, businesses, and organizations that contributed to the compilation of this book.

I received the full support of Hagerstown Fire Chief Gary Hawbaker, who recognizes the importance for every firefighter to learn from the past. Retired Firefighter/Historian William Dieterich provided vast amounts of information from his experiences as a volunteer firefighter, officer, and career driver.

The following individuals and organizations offered photographs and historical information: First Hagerstown Hose Company, Antietam Fire Company, Independent Junior Fire Company, Western Enterprise Fire Company, South Hagerstown Fire Company, Pioneer Hook & Ladder Company, Mindy Marsden and the staff of the Washington County Historical Society, John Frye and the staff of the Washington County Free Library and Western Maryland Room, Dale Swope of Photography by Dale, the Larry Allen and Company photographers, Washington County Fire and Rescue Communications Center staff including Chief Bardona Woods and Deputy Chief Roy Lescalleet, the Hagerstown Engineering Department, retired Fire Chief John Hall, retired Fire Chief Richard Smith, Battalion Chief Kyd Dieterich, William Kershner, Henry DeLauney, Harry Daveler, Debbie Daveler, Bobby Daveler, Blaine Snyder, Terry Snider, Richard Stallings, James Sprecher Jr., William Dunham, Jeff Snyder, Ryan Evans, Kitty Dorsey, James Schaffer, Sandy Tressler, Rodney McCoy, James Plummer, Richard Conrad, James Balogh, Fire Marshal Tom Brown, retired Fire Marshal John Hersh, Michael Churchy, Mable Basore, David White, Warren Jenkins, Trayer Stoops, Brenda Hawbaker, Steve Mitchell, Jackson Gearhart, William King, and William Zooker.

Thanks to the Mayhue family: my wife, Diana; daughter, Lisa; and son, Philip, for enduring endless hours of my research and writing.

Thanks to the following local media for sharing this project with the community: WHAG TV-25 news staff and Dir. Mark Kraham, *The Herald-Mail* newspaper staff, publisher John League, and photography director Kevin Gilbert.

Reference books included the following: *Chemical Fire Engines* by W. Fred Conway, 1987; *Those Magnificent Old Steam Engines* by W. Fred Conway, 1997; *The Fireman* by the American Association of Firemen, 1928; *25th Anniversary of IAFF Local 1605* booklet, 1991; *History of Western Maryland* by J. Thomas Scharf, 1968; and *A History of Washington County, Maryland* by Thomas J. C. Williams, 1906.